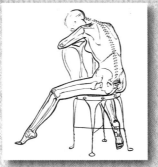

# Anatomy

**To draw or paint the human figure,** it helps to know something about the framework—the skeletal structure—on which it's built. You certainly don't need to memorize all the bones, muscles, and tendons or be able to rattle off the Latin names for each part of the human anatomy; just become familiar with the basic elements. And knowing the human skeletal and muscular structures well also helps you decide what liberties you can take to change a figure to fit a particular composition. In this book, you'll learn some simple rules of proportion, how movement and muscle affect the human structure, and the differences between male and female skeletons and musculature. If you study these diagrams and illustrations, you'll be well on your way to drawing or painting the human figure with accuracy and confidence.

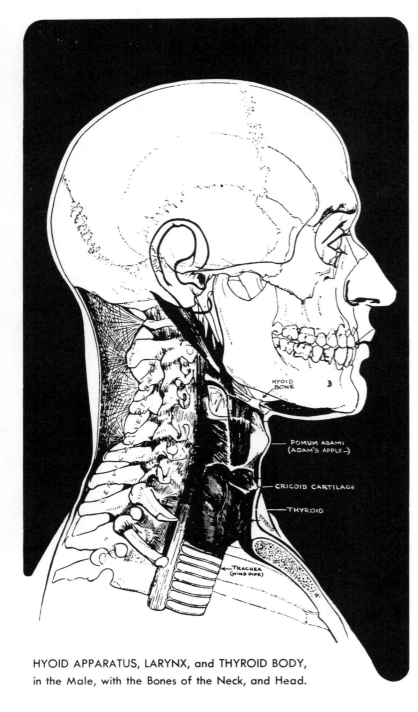

HYOID APPARATUS, LARYNX, and THYROID BODY,
in the Male, with the Bones of the Neck, and Head.

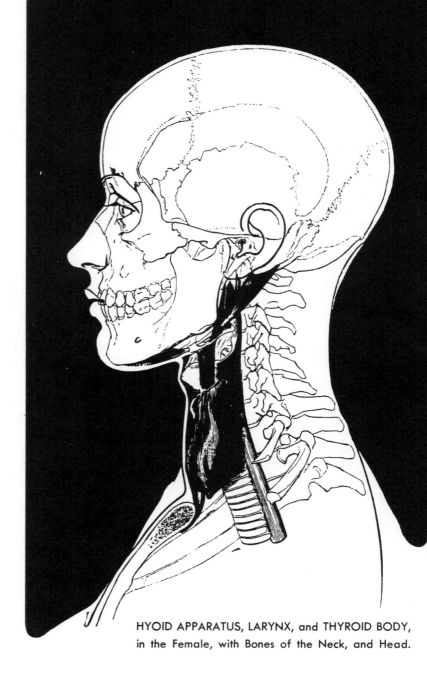

HYOID APPARATUS, LARYNX, and THYROID BODY,
in the Female, with Bones of the Neck, and Head.

Study the anatomy of the neck and head and then learn to draw it in a simplified manner. Study the limitations of the head—how far forward it can bend and how far back it can bend. Study the movement from side to side in the same manner. Learn to make quick and free sketches of the parts of the skeleton in motion—it will help you to do better drawing of a living person.

Notice the difference between the Male and Female neck and head. The lines of the male are more square, the neck seems thicker and bits of anatomy more obvious on the surface. The Female neck and head seem more graceful and have a fluid roundness of line. Try to devise your own simplification of the anatomy—such as the coil for the cervical vertebrae and the simple forms for the head. Practice and experiment — that is the way to learn.

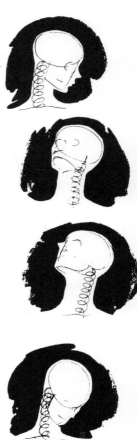

THE HUMERUS, or arm-bone, reaching from the shoulder to the elbow, is the longest, largest, and strongest bone of the upper limb. It represents the femur in the lower limb. Like the femur, it is a typical long bone, having a shaft and two articular ends; but is shorter and more slender.

In the *FOREARM*, the bones are smaller and less marked, and the radius is straighter.

The ULNA, also named the *CUBIT* (the bow or bend of the arm); is the bone on which the weight of the trunk is supported in leaning on the elbow, as in assuming the half reclining attitude of the Roman people at their meals. The ULNA is the inner of the two parallel long bones of the forearm, extending from the elbow to the wrist and is placed a little behind the other bone, the RADIUS. The ULNA is longer than the *RADIUS*, reaching higher than it, at the back of the elbow, but not quite so low at the wrist. The upper end of the ULNA is the largest part, tapering toward its lower end; whereas the *RADIUS* is smaller above and much the broadest at its lower end. Of the two bones, the ULNA contributes much the larger share to the elbow-joint, but the radius alone takes part in the formation of the wrist-joint, with which the ULNA is *not* directly connected. In the leg, both bones enter into the ankle-joint, while the *TIBIA* alone is concerned in the formation of the knee. The *RADIUS* is very peculiarly articulated with the *ULNA*, so as to be able to be rotated freely, on its longitudinal axis, upon that bone.

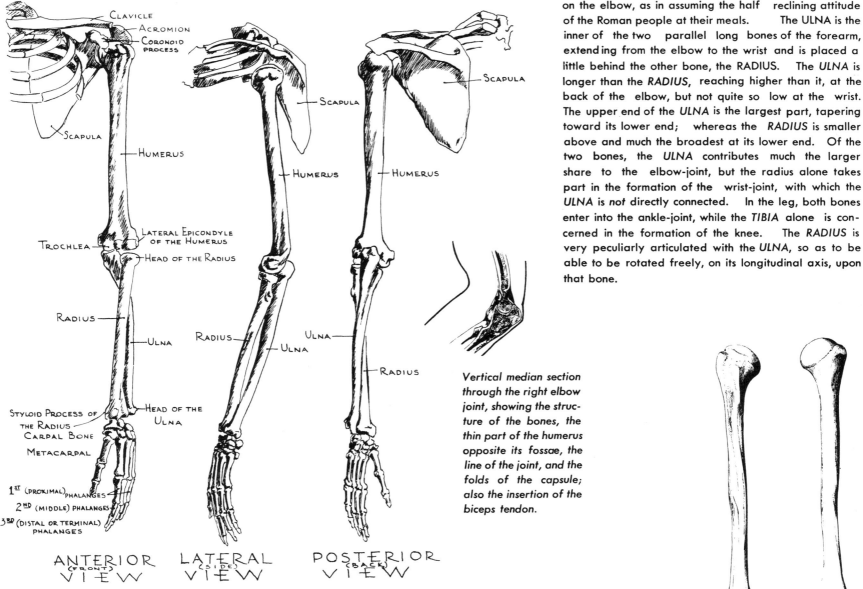

*Vertical median section through the right elbow joint, showing the structure of the bones, the thin part of the humerus opposite its fossae, the line of the joint, and the folds of the capsule; also the insertion of the biceps tendon.*

**THREE VIEWS OF THE SHOULDER JOINT OPENED**

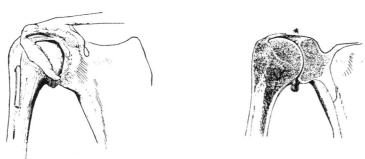

*Front view*, showing the tendon of the long head of the biceps muscle, crossing the articular cavity; also the coraco-clavicular and the acromio-clavicular ligaments.
*Vertical section* through the joint, showing the bones, the encrusting cartilage, the biceps tendon,*, and the loose capsule.
*Back view*, showing the loose capsule, and the proportionally larger part of the head of the humerus; also a small piece of the biceps tendon,*.

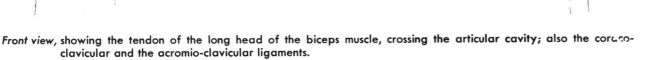

**THE LIGAMENTS OF THE ELBOW, AND SUPERIOR RADIO-ULNAR JOINTS**

*Front view*, showing the anterior and lateral ligaments. *Outer view*, showing the lateral ligament, attached to the orbicular ligament of the radius. *Inner view*, showing the internal lateral ligament, attached to ulna. *Back view*, showing the posterior ligament, and back of the lateral and orbicular ligaments.

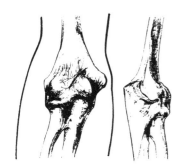
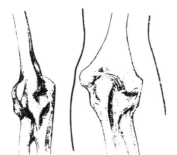
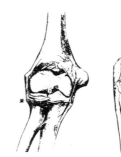

Front view of the Elbow, and Radio-ulnar joints laid open, showing the edge of the orbicular ligament of the radius,*. Outer side of the same, showing attachment of external lateral ligament to the orbicular ligament,*.

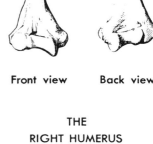

Front view    Back view

THE
RIGHT HUMERUS

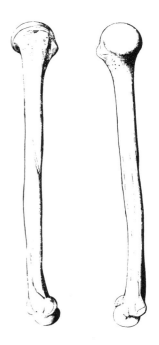

Outer side    Inner side

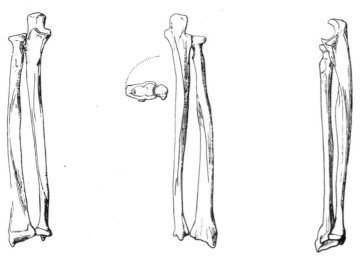

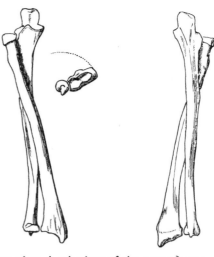

Front view, back view, and inner side of the right *RADIUS* and *ULNA*, placed parallel with each other, in the position of supination.

Front view, back view of the same bones, with the *RADIUS* across the *ULNA*, in the position of pronation.

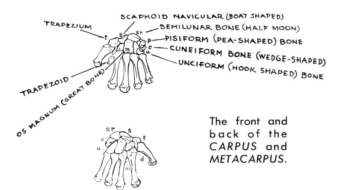

SCAPHOID NAVICULAR (BOAT SHAPED)
SEMILUNAR BONE (HALF MOON)
PISIFORM (PEA-SHAPED) BONE
CUNEIFORM BONE (WEDGE-SHAPED)
UNCIFORM (HOOK SHAPED) BONE
TRAPEZIUM
TRAPEZOID
OS MAGNUM (GREAT BONE)

The front and back of the *CARPUS* and *METACARPUS*.

(Hold one hand on the lower arm, twist and turn your arm and feel the position of the bones.)

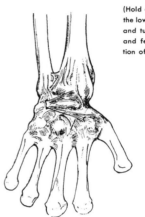

Transverse vertical section, through the inferior *RADIO-ULNAR JOINT* showing structure of the bone, the inter-articular fibro-cartilage, †, and the membrana saciculi above it. Back view of the ligaments of the *WRIST JOINT*, and of the inferior radio carpal, and metacarpal ligaments. The same view with the *WRIST JOINT*, and the *TRANSVERSE CARPAL JOINT* both laid open.

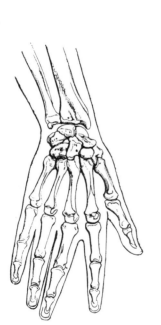

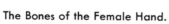

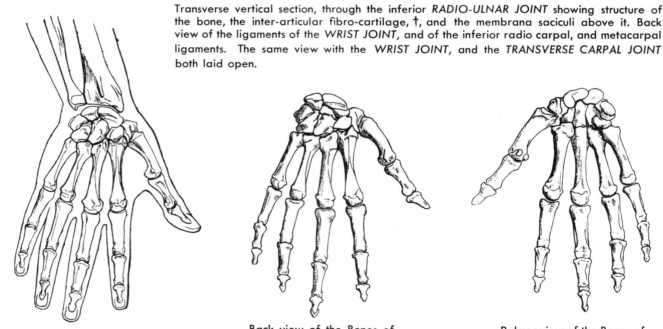

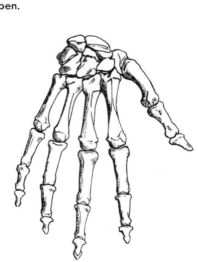

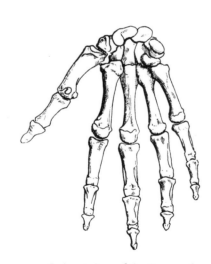

The Bones of the Female Hand.

The Bones of the Male Hand.

Back view of the Bones of the Right Hand.

Palmer view of the Bones of the Right Hand.

Study your own hands in use—study photographs of hands—make anatomical sketches of them in as simple a design as you can devise.

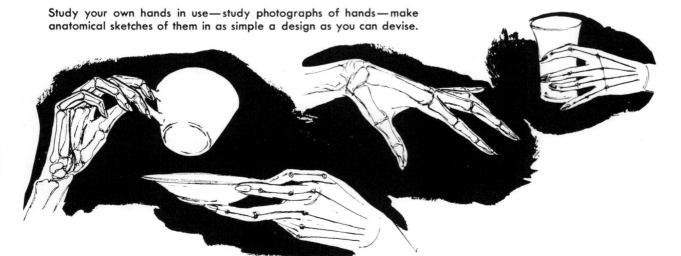

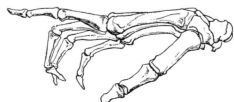

Outer Border of the Right Hand.

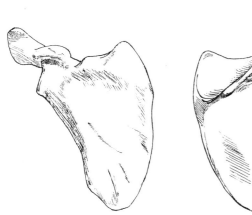
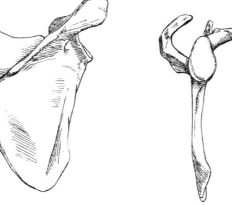

THE SCAPULA

FRONT VIEW          BACK VIEW          AUXILIARY BORDER

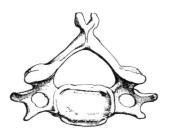
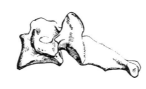

UPPER VIEW AND LEFT SIDE OF THE FOURTH CERVICAL VERTEBRA.

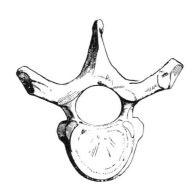
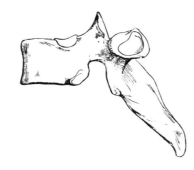

UPPER VIEW AND LEFT SIDE OF THE SIXTH DORSAL VERTEBRA.

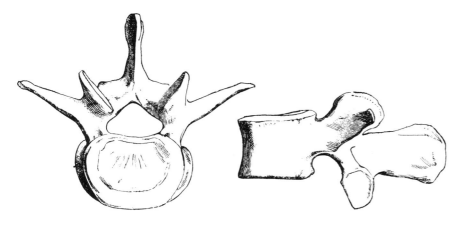

UPPER VIEW AND LEFT SIDE OF THE THIRD LUMBAR VERTEBRA.

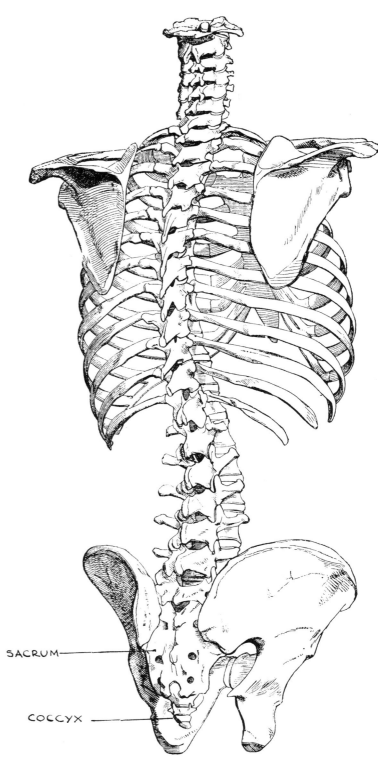

SACRUM

COCCYX

THREE-QUARTER BACK VIEW OF THE BONES OF THE TRUNK,—INCLUDING THE PELVIC AND SHOULDER-GIRDLES.

The *MOVEABLE* part of the vertebral column extends from the base of the skull to the base of the sacrum—it occupies the regions of the neck, back, and loins. The back consists of 24 vertebrae—number them downwards from the base of the skull— 1st to 7th *CERVICAL*, 1st to 12th *DORSAL*, and 1st to 5th *LUMBAR*; they are connected by a series of interposed fibro cartilaginous discs.

The *CERVICAL* vertebrae, with the exception of the lowest, are distinguished by having their transverse processes perforated at the base. The twelve *DORSAL* vertebrae are quite peculiar in being connected each with a pair of moveable ribs.

The lower, *IMMOVEABLE* part of the vertebral column or spine consists of the sacrum and the coccyx.

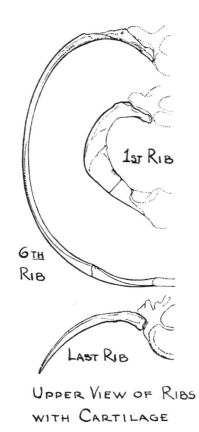

1ST RIB

6TH RIB

LAST RIB

UPPER VIEW OF RIBS
WITH CARTILAGE

FRONT VIEW

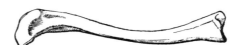

UPPER VIEW
THE RIGHT CLAVICLE

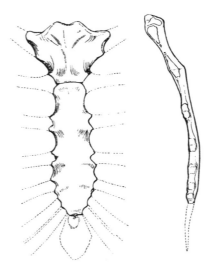

FRONT VIEW   RIGHT BORDER
STERNUM

The CLAVICLES or collar bones pass across the front of the upper part of the THORAX and the lower part of the neck—are placed nearly horizontally, one on each side between the top of the STERNUM, just above the first costal cartilage and rib, and the acromion process of the scapula.

The STERNUM, or breast-bone is a flattened median bone that fits in between the cartilages of the upper seven ribs so as to close in the chest front. The entire bone has been compared to a short, straight sword like a Roman sword. Its lower, middle and upper parts have been named respectively — the POINT, the BLADE, and the HANDLE.

The THORAX or chest has for its osseous and cartilaginous frame work, the twelve DORSAL, rib-bearing vertebrae behind, the twenty-four ribs with their cartilages at the sides, and the STERNUM or breast-bone in front. The ribs form both sides of the THORAX and assists in completing its walls, both in front and behind.

The *first* cervical vertebra is named ATLAS because it supports the head as the hero Atlas supported the earth. The *second* cervical vertebra is called the AXIS. It is somewhat deeper in front from above downwards than the one below and its upper surface is not flattened for the attachment of an intervertebral disc to connect it with the under surface of the vertebra above.

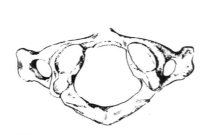

FIRST CERVICLE VERTEBRA
OR ATLAS..

LEFT SIDE OF THE ATLAS

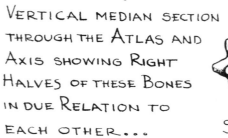

VERTICAL MEDIAN SECTION
THROUGH THE ATLAS AND
AXIS SHOWING RIGHT
HALVES OF THESE BONES
IN DUE RELATION TO
EACH OTHER...

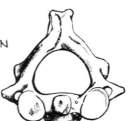

SECOND CERVICAL
VERTEBRA OR AXIS..

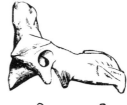

LEFT SIDE OF SECOND
CERVICAL VERTEBRA.

THREE-QUARTER FRONT
VIEW WITH PELVIC AND
SHOULDER-GIRDLES.

6

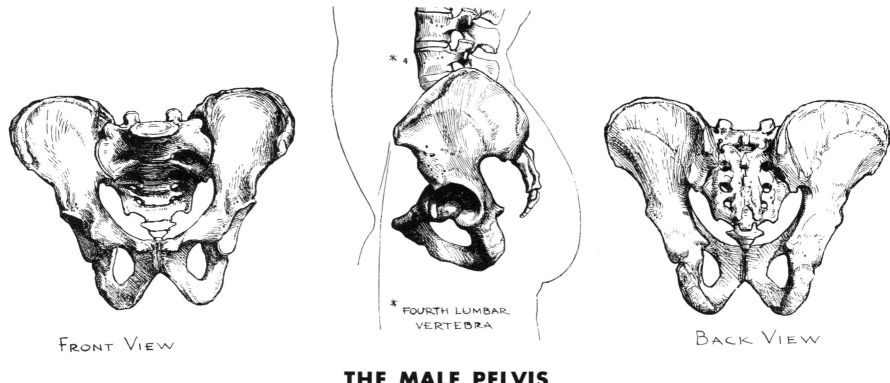

FRONT VIEW

* FOURTH LUMBAR VERTEBRA

BACK VIEW

## THE MALE PELVIS

Compare the deficient height of the female *PELVIS* to that of the male—notice the less massive form of the female (it is especially obvious in the side views). The most numerous differences between the skeleton of the male and female are to be found in the *PELVIS*. Regarded from front or back—the *FEMALE PELVIS* is wider, but vertically shorter or more shallow than the *MALE PELVIS* which is narrow and long. The pelvic parts are all smoother, lighter and weaker in the female; the aloe of the ilic bones are thinner, broader, flatter, and more expanded. The crests of the ilia are longer but shallower, not rising up so high; the crests are also further apart so that the average extreme width from one crest to another is greater, though their height is less.

## THE FEMALE PELVIS

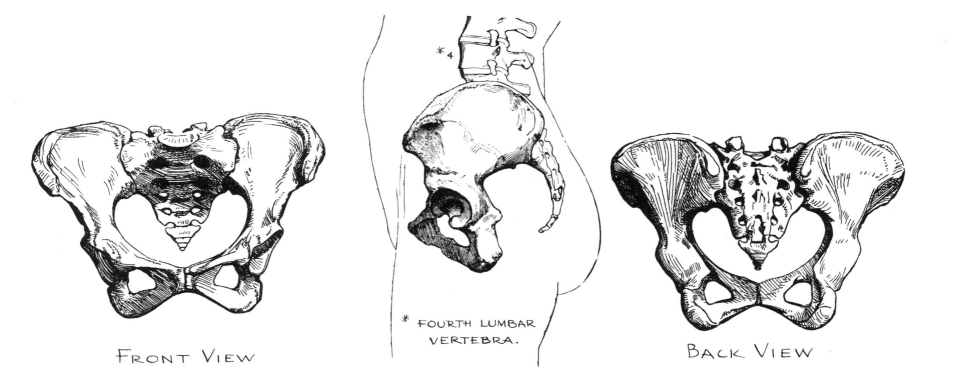

FRONT VIEW

* FOURTH LUMBAR VERTEBRA.

BACK VIEW

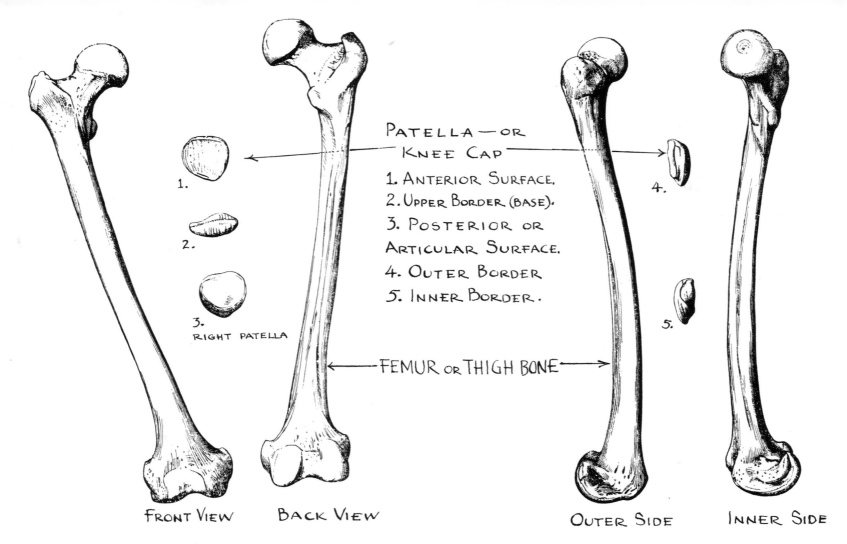

PATELLA — OR
KNEE CAP
1. ANTERIOR SURFACE.
2. UPPER BORDER (BASE).
3. POSTERIOR OR
ARTICULAR SURFACE.
4. OUTER BORDER
5. INNER BORDER.

RIGHT PATELLA

FEMUR or THIGH BONE

FRONT VIEW    BACK VIEW        OUTER SIDE    INNER SIDE

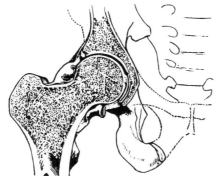

Vertical section through the *HIP JOINT* showing structure of the bones, the encrusting cartilage, the ligamentum teres, and the loose folded capsule.

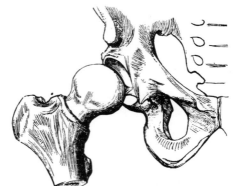

The *HIP JOINT* seen from the front, and laid open to show the acetabulum, the cotyloid ligament, and the ligamentum teres.

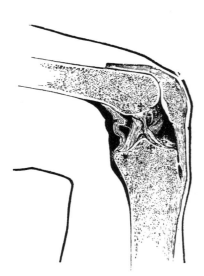

Vertical median section through the *KNEE JOINT* showing the bones covered with articular cartilage, the posterior ligament, and the ligamentum *PATELLAE* with the bursa between it and the *TIBIA*.

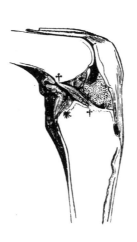

Vertical section made to the outer side of the middle line. Anterior crucial ligament, and posterior crucial ligament. In front of these is the fatty tissue of the ligamentum mucosum, behind the ligamentum patellae.

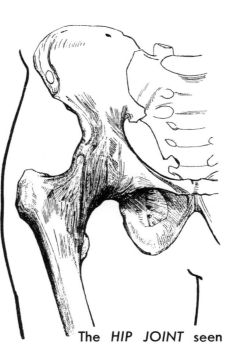

The *HIP JOINT* seen from the front and closed, showing the capsule and the accessory ligaments; also the symphysis pubis, and the obturator membrane.

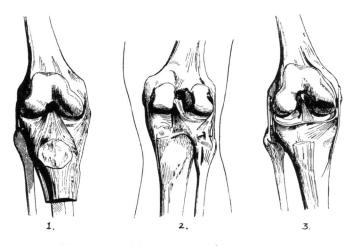

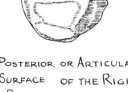

POSTERIOR OR ARTICULAR
SURFACE OF THE RIGHT
PATELLA SHOWING
ITS SEVEN
SUBORDINATE FACETS.

## THE KNEE JOINT LAID OPEN

1. Front view of the patella turned down, showing its articular surface, and a part of the extensor tendon with the ligamentum mucosum.

2. Back view showing crucial ligaments, and posterior margins of the semilunar fibro-cartilages.

3. Front view, the femur thrown back a little, the patella with a greater part of its ligament having been removed; it shows crucial ligaments and anterior margins of the semilunar fibro-cartilages.

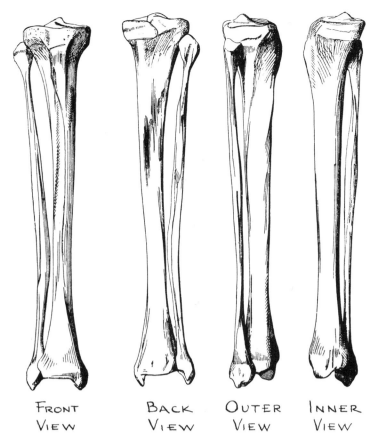

FRONT VIEW     BACK VIEW     OUTER VIEW     INNER VIEW

## THE RIGHT TIBIA AND FIBULA

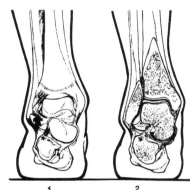

1. Articular surfaces of the OS CALCIS and ASTRAGALUS belonging to the TRANSVERSE JOINT of the TARSUS; the ANKLE JOINT laid open in front.

2. Vertical TRANSVERSE SECTION through the ASTRAGALO-CALCANEAL JOINT and the ankle joint. *, the interosseous astragalo-calcaneal ligament.

3. Longitudinal section through all the joints along the inner border of the FOOT and through the middle of the ankle joint. †, inferior calcaneo-scaphoid ligament. *, interosseous astragalo-calcaneal ligament. 9', tendon of tibialis posticus muscle.

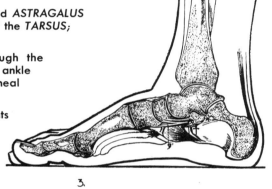

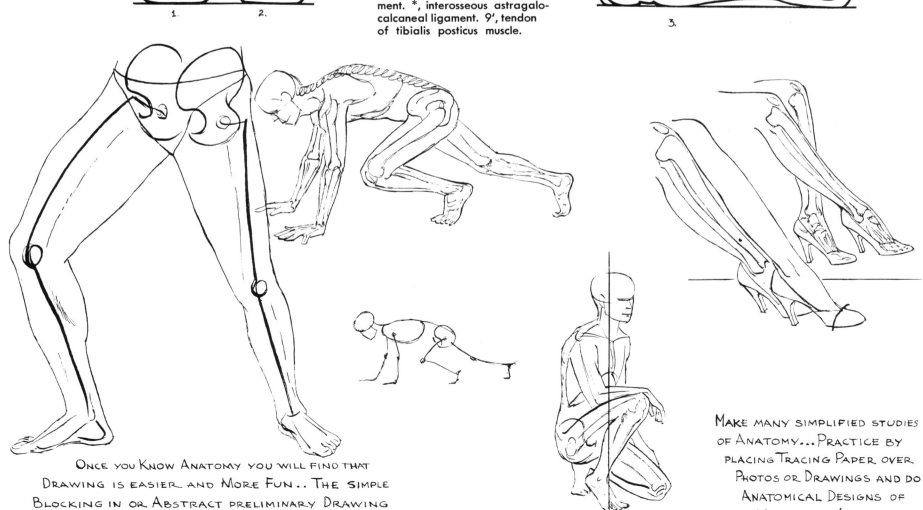

ONCE YOU KNOW ANATOMY YOU WILL FIND THAT
DRAWING IS EASIER AND MORE FUN.. THE SIMPLE
BLOCKING IN OR ABSTRACT PRELIMINARY DRAWING
IS THE IMPORTANT SKELETON OF YOUR FINAL SKETCH.
LEARN TO DRAW WITH AUTHORITY..

MAKE MANY SIMPLIFIED STUDIES
OF ANATOMY... PRACTICE BY
PLACING TRACING PAPER OVER
PHOTOS OR DRAWINGS AND DO
ANATOMICAL DESIGNS OF
YOUR OWN!

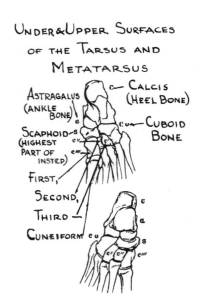

UNDER & UPPER SURFACES
OF THE TARSUS AND
METATARSUS

ASTRAGALUS
(ANKLE
BONE)
CALCIS
(HEEL BONE)
SCAPHOID
(HIGHEST
PART OF
INSTEP)
CUBOID
BONE

FIRST,
SECOND,
THIRD —
CUNEIFORM

THE CUBOID, THREE CUNEIFORM,
& THE SCAPHOID BONES FORM
THE ANTIOR GROUP OF THE TARSAL
BONES. THE METARSUS HAS FIVE
BONES — ON FOR THE SUPPORT
OF EACH TOE..

In the *LOWER* pair of appendages or *LIMBS,* the first long bone is the *FEMUR* or thigh-bone. It is the longest, heaviest, and strongest of the long bones. The *FEMUR* is articulated very moveably above with the *HIP-BONE,* and below at the *KNEE-JOINT* with the larger *only* of the two bones of the leg. This larger bone is named *TIBIA.* The *TIBIA* occupies the front and inner side of the leg which the smaller bone of the lower limb is somewhat posteriorly and along the outer aspect of the leg—it is the *FIBULA* (a tie or brace to the *TIBIA*). The *TIBIA* is a massive bone and enters into the formation of the knee-joint; the *FIBULA,* comparatively slender, does not reach so high as the knee, but is connected by a slightly moveable joint with the side of the upper end of the *TIBIA.* The knee joint is completed in front by a peculiar short flattened bone which does not belong to the endo-skeleton, but to the muscular tendinous system named the *PATELLA* (little plate).

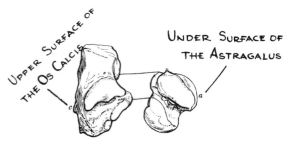

UPPER SURFACE OF
THE OS CALCIS

UNDER SURFACE OF
THE ASTRAGALUS

RIGHT FOOT

FRONT VIEW OF
THE ASTRAGALUS

UPPER VIEW OF
THE SCAPHOID

At the *ANKLE,* where motion is free, the *TIBIA* enters mainly into the formation of the joint (the *FIBULA* contributing only to the completion of its outer side). The *TIBIA* forms the upper surface and inner side of the ankle. The two bones of the leg are fastened together below, as well as above, so securely that there is no rolling movement like that of the radius and the ulna in the forearm—but only a limited gliding movement.

The *FOOT,* like the hand, is divisible into three componant parts which are named the *TARSUS, METATARSUS,* and the *PHALANGES* of the toes. The *TARSUS,* (broad portion of the foot) includes the *ANKLE, HEEL,* and *INSTEP;*—it is much more massive than the carpus or wrist. The *METATARSUS* (beyond the instep)—is longer and stronger than the metacarpus in the hand while the *PHALANGES* of the toes are shorter than those of the fingers and thumbs, and in the case of the four outer toes, though not in that of the great toe, much smaller and more slender. The *TARSUS* is composed of seven bones, not of eight like the carpus, which are short and strong; they are not arranged in two distinct rows as in the carpus, but rather in two groups.

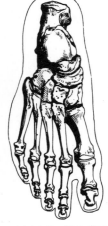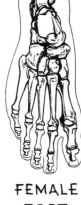

MALE FOOT     FEMALE
              FOOT

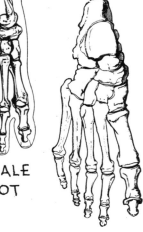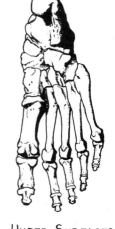

UPPER SURFACES
OF THE BONES OF
THE FOOT...

UNDER SURFACES
OF THE BONES OF
THE FOOT...

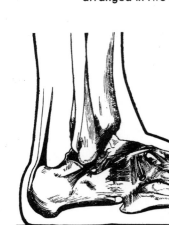

LIGAMENTS OF THE TOES, TARSUS,
METATARSUS & ANKLE JOINT, SEEN
ON OUTER & INNER SIDES OF THE FOOT..

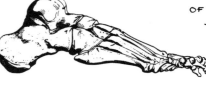

OUTER BORDER OF THE
BONES OF THE FOOT...

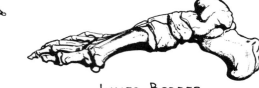

INNER BORDER

MAKE STUDIES OF YOUR OWN FEET &
LEGS. MAKE ANATOMICAL STUDIES
ON TRACING PAPER OVER THESE &
OTHER DRAWINGS...

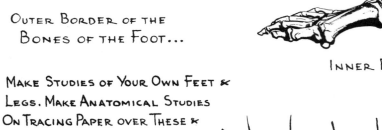

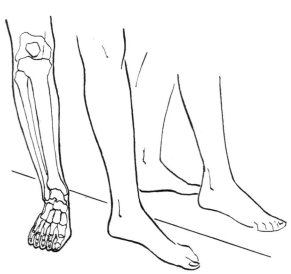

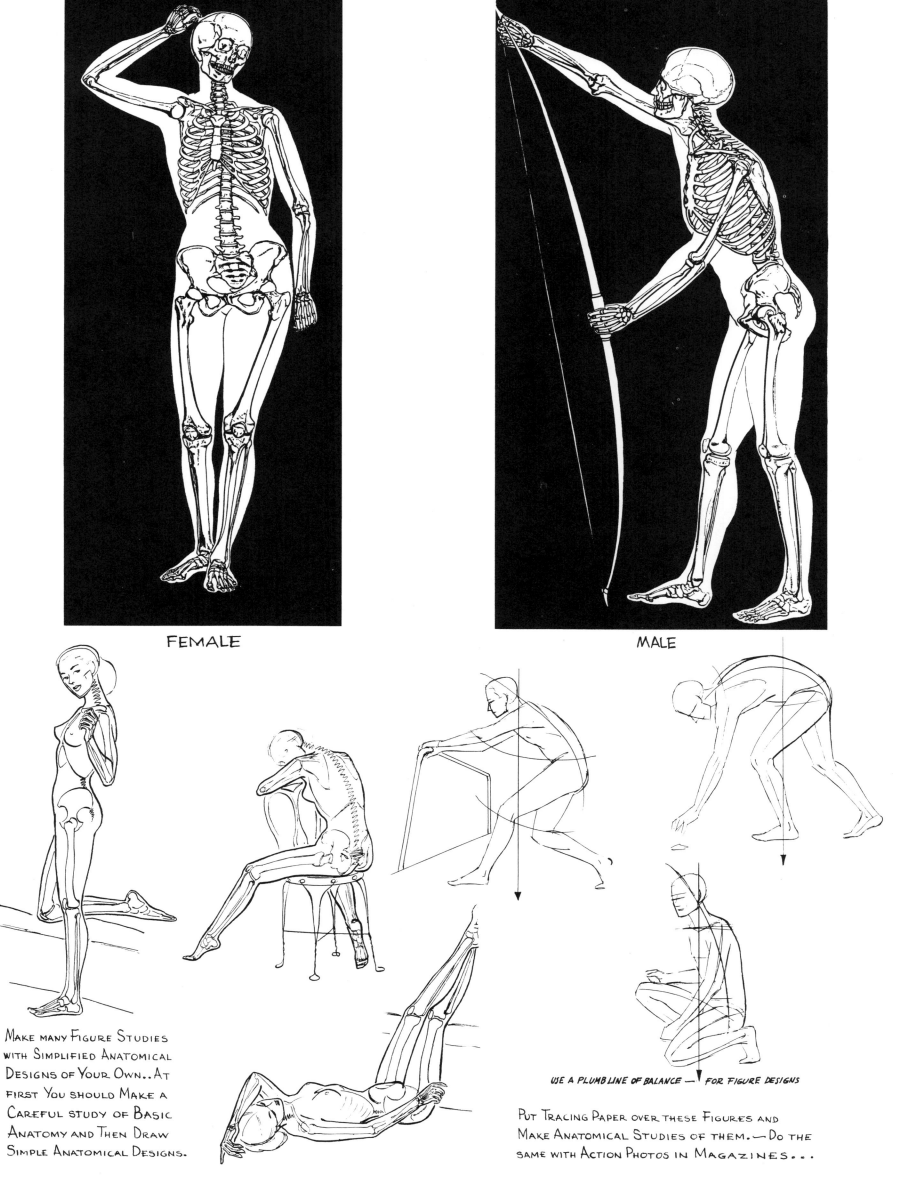

FEMALE

MALE

MAKE MANY FIGURE STUDIES
WITH SIMPLIFIED ANATOMICAL
DESIGNS OF YOUR OWN..AT
FIRST YOU SHOULD MAKE A
CAREFUL STUDY OF BASIC
ANATOMY AND THEN DRAW
SIMPLE ANATOMICAL DESIGNS.

USE A PLUMB LINE OF BALANCE ──▼ FOR FIGURE DESIGNS

PUT TRACING PAPER OVER THESE FIGURES AND
MAKE ANATOMICAL STUDIES OF THEM.── DO THE
SAME WITH ACTION PHOTOS IN MAGAZINES...

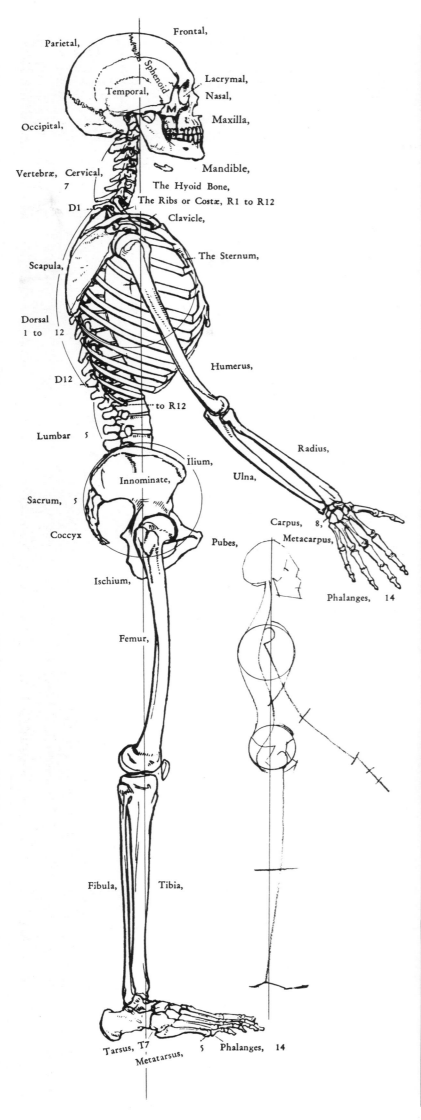

Parietal,
Frontal,
Sphenoid
Temporal,
Lacrymal,
Nasal,
M
Maxilla,
Occipital,
Vertebræ, Cervical, 7
Mandible,
The Hyoid Bone,
The Ribs or Costæ, R1 to R12
D1
Clavicle,
Scapula,
The Sternum,
Dorsal 1 to 12
D12
Humerus,
to R12
Lumbar 5
Radius,
Ilium,
Ulna,
Innominate,
Sacrum, 5
Coccyx
Pubes,
Carpus, 8,
Metacarpus,
Ischium,
Phalanges, 14
Femur,
Fibula, Tibia,
Tarsus, T7
Metatarsus, 5
Phalanges, 14

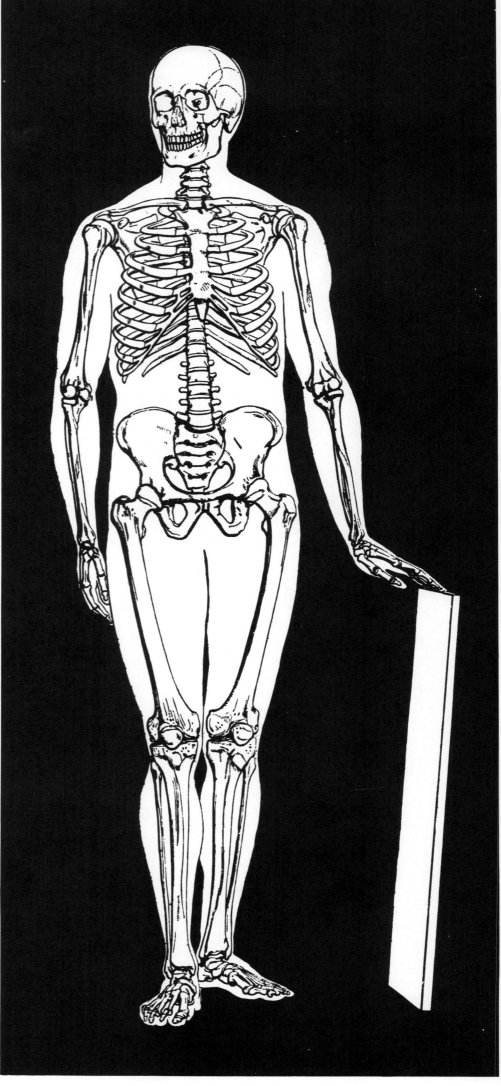

## TABLE OF THE BONES

THE FOLLOWING table constitutes a reference and will help the memory, as regards the names of the bones, and their position in the skeleton; it also gives the number of bones in each great subdivision of the body, as well as the total number in the whole skeleton. The shoulder-girdle and hip-girdle are here placed in conjunction with their respective extremities. The two patellae are not enumerated as bones of the skeleton proper; nor are certain little *ossicles,* six in number, belonging to the ears, though these latter deserve to be so considered.

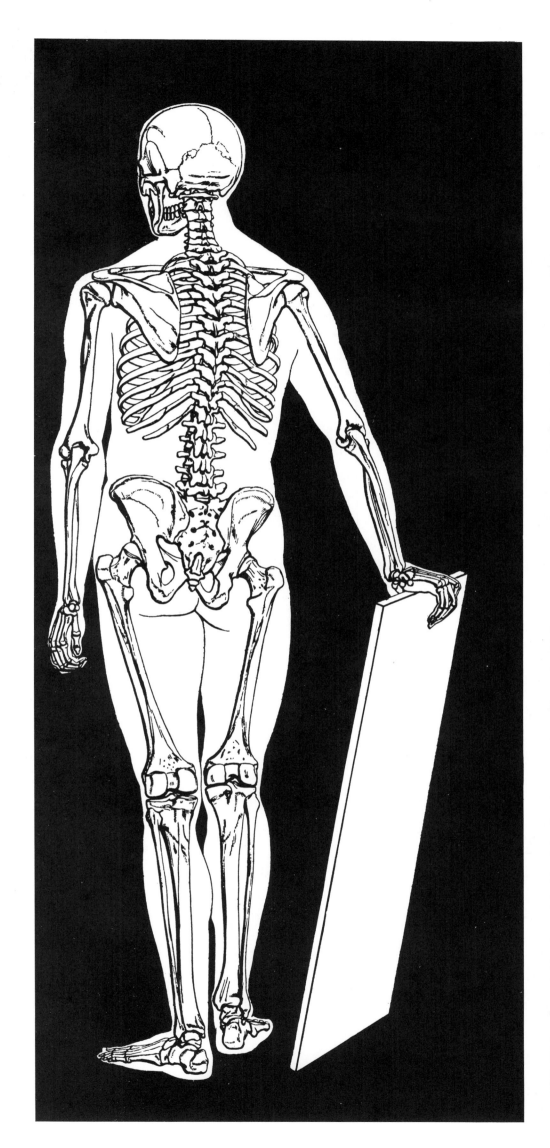

```
The Head  .   .   .   .   .   .   .   .   .   . 22
     The Cranium, 8, viz.—
          Occipital, O  .   .   .   .   .   1
          Parietal, P  .   .   .   .   .   2
          Frontal, F  .   .   .   .   .   1
          Temporal, T  .   .   .   .   .   2
          Sphenoid, S  .   .   .   .   .   1
          Ethmoid  .   .   .   .   .   .   1
     The Face, 14, viz.—
          Malar, M  .   .   .   .   .   2
          Superior Maxillary, J  .   .   .   2
          Nazal, N  .   .   .   .   .   2
          Lacrymal, L  .   .   .   .   .   2
          Inferior Maxillary, J'  .   .   .   1
The Hyoid Bone, h .   .   .   .   .   .   .   .   . 1
          Palate  .   .   .   .   .   .   2
          Turbinated  .   .   .   .   .   2
          Vomer  .   .   .   .   .   .   1
The Spine  .   .   .   .   .   .   .   .   .   . 26
          Vertebrae, Cervical, C7  .   .   7
             "      Dorsal, D1 to D12  . 12
             "      Lumbar, L5  .   .   .   5
          Sacrum, S5  .   .   .   .   .   1
          Coccyx, C  .   .   .   .   .   .   1
The Ribs or Costae, R1 to R12  .   .   .   .   . 24
The Sternum, St  .   .   .   .   .   .   .   .   . 1
The Upper Extremities .   .   .   .   .   .   .   . 64
          Clavicle, Cl  .   .   .   .   .   2
          Scapula, Sc  .   .   .   .   .   2
          Humerus, H  .   .   .   .   .   2
          Ulna, U  .   .   .   .   .   .   2
          Radius, R  .   .   .   .   .   .   2
          Carpus, C8, viz.—  .   .   .   . 16
               Semilunar, sr
               Cuneiform, c
               Pisiform, p
               Scaphoid, s
               Trapezium, t
               Trapezoid, d
               Os magnum, m
               Unciform, u
          Metacarpus, Mc5  .   .   .   . 10
          Phalanges, P14  .   .   .   .   . 28
The Lower Extremities  .   .   .   .   .   .   .   . 60
          Innominate, I  .   .   .   .   .   2
               Ilium, i
               Ischium, s
               Pubes, p
          Femur, Fe  .   .   .   .   .   2
          Tibia, Ti  .   .   .   .   .   .   2
          Fibula, Fi  .   .   .   .   .   .   2
          Tarsus, T7  .   .   .   .   .   . 14
               Astragalus, a
               Os calcis, c
               Scaphoid, s
               Three Cuneiform, c',",'"
               Cuboid, cu
          Metatarsus, Mt5  .   .   .   . 10
          Phalanges, P14  .   .   .   .   . 28
                                          ———
               Total  .   .   .   .   .   .   . 198
```

The long bones are always curved. Some, like the femur, present a single curve; others are curved in two directions, like the collar-bone, while others, again, like the ulna and the ribs, present complex curves, accompanied often with a twist or torsion. All such curvatures increase the elasticity and, so far, the resisting power of the bone; they also serve to enlarge the surface of attachment for muscles, and to furnish the means of giving special direction to certain portions of a muscle.

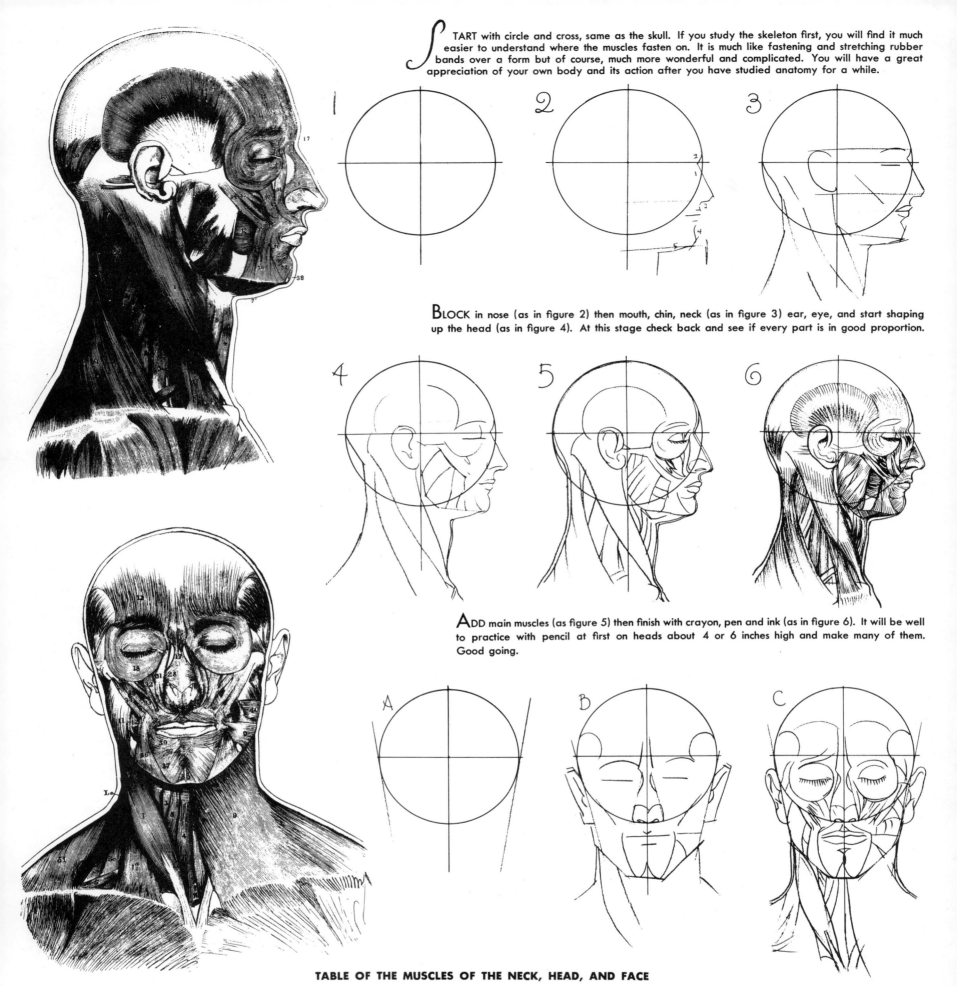

$\int$ TART with circle and cross, same as the skull. If you study the skeleton first, you will find it much easier to understand where the muscles fasten on. It is much like fastening and stretching rubber bands over a form but of course, much more wonderful and complicated. You will have a great appreciation of your own body and its action after you have studied anatomy for a while.

$B$LOCK in nose (as in figure 2) then mouth, chin, neck (as in figure 3) ear, eye, and start shaping up the head (as in figure 4). At this stage check back and see if every part is in good proportion.

$A$DD main muscles (as figure 5) then finish with crayon, pen and ink (as in figure 6). It will be well to practice with pencil at first on heads about 4 or 6 inches high and make many of them. Good going.

## TABLE OF THE MUSCLES OF THE NECK, HEAD, AND FACE

### THE HEAD AND FACE

*Masticatory Group*
Temporalis, 10.
Masseter, 11.
Buccinator, 12.

*Epicranial Group*
Occipito-frontalis, 13, 13'.
Corrugator supercilii, 17.

*Auricular Group*
Attrahens aurem, 14.
Attollens aurem, 15, 15'.
Retrahens aurem, 16.

*Ocular Group*
Rectus superior, 21.
Rectus inferior, 22.
Rectus externus, 23.
Rectus internus, 24.
Obliquus superior, 25.
Obliquus inferior, 26.

*Palpebral Group*
Levator palpebræ superioris, 19.
Tensor tarsi, 20.
Orbicularis palpebrarum, 18.
(*Tendo palpebrarum*, T O).

*Nasal Group*
Pyramidalis, nasi, 27.
Compressor alæ nasi, 28.
Dilatatores naris.
Depressor alæ nasi, 30.
Levator labii superioris alæque nasi, 31.

*Labial Group*
Levator labii superioris, 32.
Levator anguli oris, 33.
Zygomaticus major, 34.
Zygomaticus minor, 35.
Depressor anguli oris, or Triangularis oris, 36.
Depressor labii inferioris, or Quadratus menti, 37.
Levator labii inferioris, or Levator menti, 38.
Orbicularis, 39.
Risorius, 40.

### THE NECK

Sterno-cleido-mastoid, 1, 1a.
Sterno-thyroid, 2.
Thyro-hyoideus, 3.
Sterno-hyoideus, 4.
Omo-hyoideus, 5, 5.
Mylo-hyoideus, 6.
Digastricus, 7, 7'.
Stylo-hyoideus, 8.
Platysma myoides, 9.

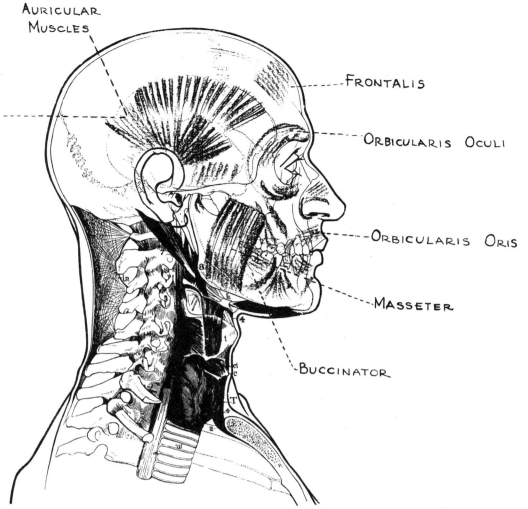

AURICULAR MUSCLES

FRONTALIS

ORBICULARIS OCULI

ORBICULARIS ORIS

MASSETER

BUCCINATOR

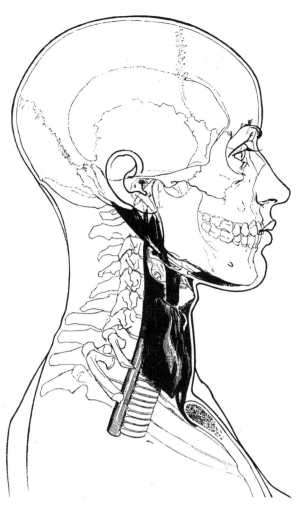

## HYOID APPARATUS, LARYNX, AND THYROID BODY IN THE MALE, with the Bones and Muscles of the Neck and Head

Below the larynx, the thyroid body, T, which is covered by the depressor muscles of the hyoid bone, chiefly determines the general surface-forms of the throat. In the shorter, thicker neck of the male, this body—the function of which is not determined, sinks backwards, and retires even beneath the top of the sternum; whereas, in the longer, and more slender "swan-like" female neck, it is longer and relatively fuller, especially below, where it gives rise to the peculiar smooth contour of the lower part of the female throat, and produces a rounded fulness on either side of the middle line, a beauty sufficiently appreciated by artists. Between the Pomum Adami and the suprasternal notch, the outline of the male throat sometimes shows a second smaller eminence due to the cricoid cartilage, c. In the female, this cartilage is not perceptible on the surface and the profile line pursues a long, gentle and uninterrupted curve from the thyroid eminence down to the root of the neck. The great difference in the size, shape and proportions of the cranium and face, in the two sexes, are illustrated in these two heads.

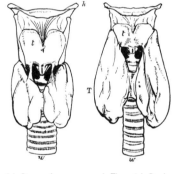

Hyoid Bone, Larynx, and Thyroid Body of the Male. The same parts in the Female.

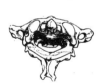

Posterior view of the transverse atlanto-axial ligament, and its upward and downward slips, constituting the cruciform ligament.

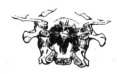

Posterior view of the occipito-axial or odontoid ligaments, namely, the central ligament and the two alar, or check ligaments.

Deep Muscles of the Nose and Lips, in Section.

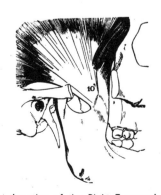

Insertion of the Right Temporal Muscle.

## HYOID APPARATUS, LARYNX, AND THYROID BODY IN THE FEMALE, with the Bones of the Neck and Head

The Coronoid process is removed, to show the external petrogoid muscle with some of its fibres attached to the cartilage. The two joints of the lower jaw represent a double hinge, which acts with great security up and down; it also permits direct backward and forward movements, and lateral horizontal ones of the whole bone, latter being dependent on alternate oblique forward and backward movements of one or the other condyle. All these movements are employed during mastication, providing not merely for the closure of the jaws, but also for the rotation of the lower teeth beneath the upper ones. It is important to note that, in opening the mouth, which occurs not only in eating, but in oratory, in singing, in yawning, and in the expression of certain strong or startling emotions, the condyles, and with them the whole lower jaw, move a little forwards; at the same time, both the body and rami change their direction in regard to neighboring parts, though not to each other. In closing the mouth, the condyles again move backward, but the angle and the chin are carried forwards, the rami and body recovering their respective positions in reference to adjacent parts. The backward and forward movements of the jaw are employed in grimacing, and so, in fact, are the side to side motions of the chin, in making *wry* faces.

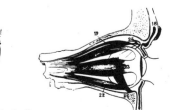

Muscles of the Right Eyeball, within the orbit, seen from the front.

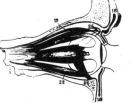

The same, seen from the outer side.

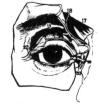

The Muscles of the Right Eyebrow and Eyelids.

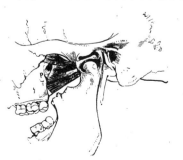

The Articulation of the Lower Jaw laid open, to show the inter-articular cartilage.

The Ligaments of the left side of the Lower Jaw.

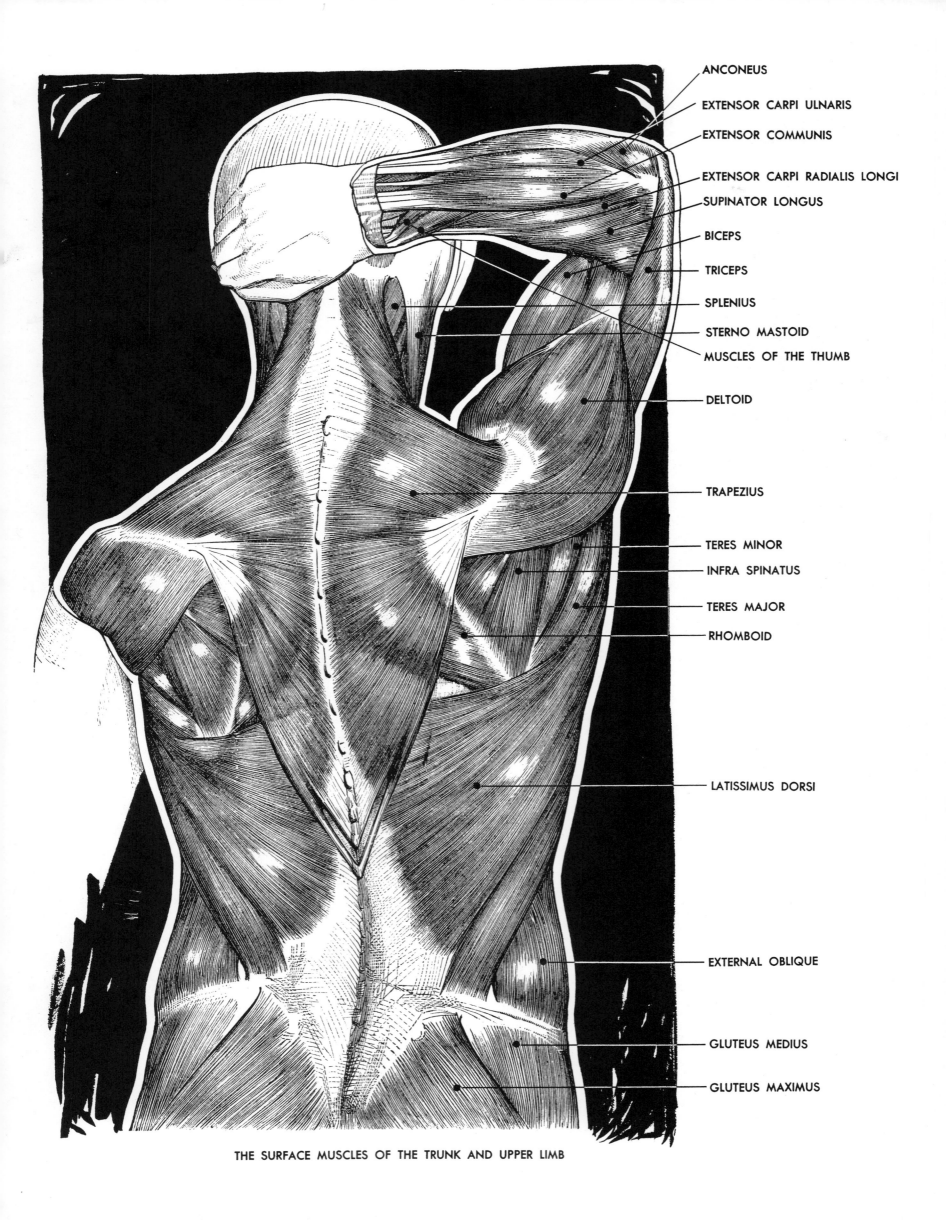

ANCONEUS

EXTENSOR CARPI ULNARIS

EXTENSOR COMMUNIS

EXTENSOR CARPI RADIALIS LONGI

SUPINATOR LONGUS

BICEPS

TRICEPS

SPLENIUS

STERNO MASTOID

MUSCLES OF THE THUMB

DELTOID

TRAPEZIUS

TERES MINOR

INFRA SPINATUS

TERES MAJOR

RHOMBOID

LATISSIMUS DORSI

EXTERNAL OBLIQUE

GLUTEUS MEDIUS

GLUTEUS MAXIMUS

THE SURFACE MUSCLES OF THE TRUNK AND UPPER LIMB

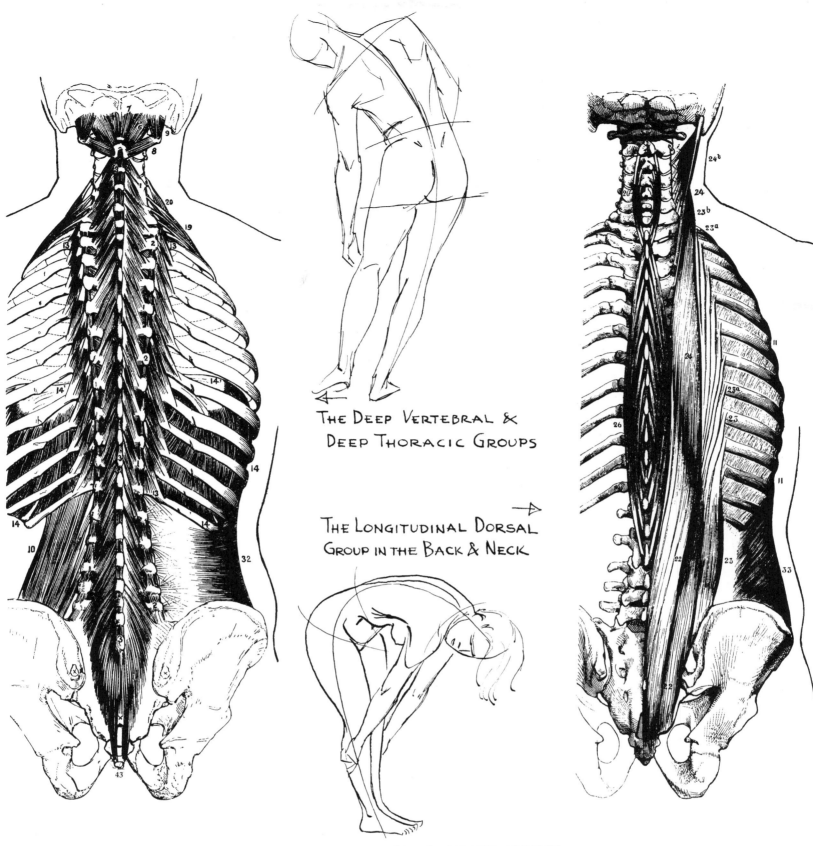

The Deep Vertebral &
Deep Thoracic Groups

The Longitudinal Dorsal
Group in the Back & Neck

## TABLE OF THE MUSCLES OF THE TRUNK

*THE DEEP VERTEBRAL GROUP*

Multifidus spinæ, 1

Rotatores spinæ, 1

Inter-transversales, 2

Inter-spinales, 3

Semi-spinalis dorsi, 4

Semi-colli, 5

Rectus capitis posticus major, 6

Rectus capitis posticus minor, 7

Obliquus capitis inferior, 8

Obliquus capitus superior, 9

*THE PRAE-VERTEBRAL GROUP*

Longus colli, 15

Rectus capitis lateralis, 16

Rectus capitis anticus minor, 17

Rectus capitis anticus major, 18

Rectum Enrightus major, 43

*THE DEEP THORACIC GROUP*

Quadratus lumborum, 10

Diaphragm, 14

Triangularis sterni, 31

Intercostales interni, 11

Intercostales externi, 12

Levatores costarum, 13

Scalenus posticus, 19

Scalenus medius, 20

Scalenus anticus, 21

*THE LONGITUDINAL DORSAL GROUP*

Erector spinæ, 22

Sacro-lumbalis, 23

Musculus accessorius, 23a

Cervicalis ascendens, 23b

Longissimus dorsi, 24

Transversalis colli, 24a

Trachelo-mastoid, 24b

Complexus, 25

Biventer cervicis, 25a

Spinalis dorsi, 26

Spinalis colli, 26a

(Lumbar fascial), 27

(Vertebral aponeurosis), 27a

(Continued on page 18)

THE DIVERGENT DORSAL
GROUP IN THE BACK &
NECK WITH THE LUMBAR
& VERTEBRAL FASCIÆ

THE LATISSIMUS DORSI
OF THE SUPERFICIAL
DORSAL GROUP

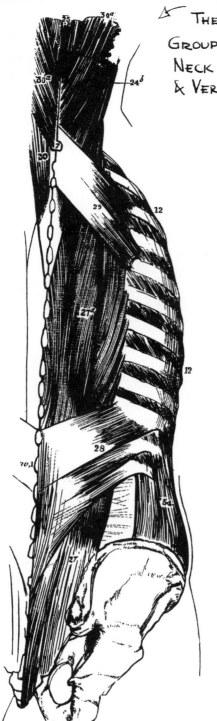

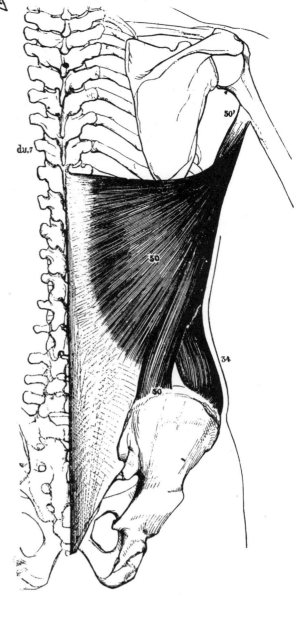

### THE DIVERGENT DORSAL GROUP

Serratus posticus inferior, 28
Serratus posticus superior, 29
Splenius colli, 30
Splenius capitis, 30a

### THE ABDOMINAL GROUP

Transversalis abdominis, 32
Obliquus externus abdominis, 34
Rectus abdominis, 35
Pyramidalis, 36
Sheath of the rectus 37
Lineæ alba, 38
Lineæ transversae, 39
Lineæ semilunares, 40

### THE SHOULDER-GIRDLE GROUP

Levator anguli scapulae, 41
Rhomboideus minor, 42
Rhomboideus major, 43
Serratus magnus, 44

### THE SCAPULAR GROUP

Subscapularis, 45
Supra-spinatus, 46
Infra-spinatus, 47
Teres minor, 48
Teres major, 49

### THE SUPERFICIAL DORSAL GROUP

Latissimus dorsi, 50
Trapezius, 51

### THE PECTORAL GROUP

Subclavius, 53
Pectoralis minor, 54
Pectoralis major, 55

### THE SHOULDER-CAP MUSCLE

Deltoid, 52

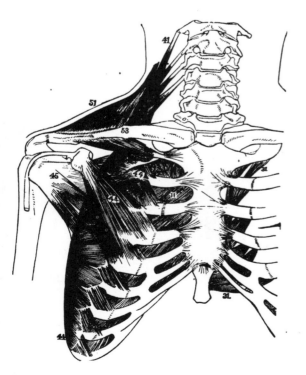

DEEP PORTION OF THE PECTORAL
GROUP WITH PARTS OF THE SHOULDER-
GIRDLE GROUP, & OF THE TRAPEZIUS

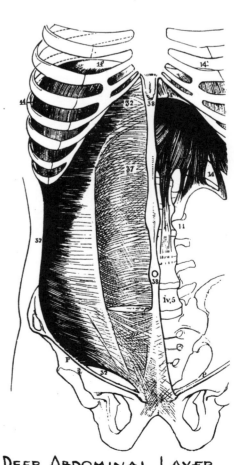

DEEP ABDOMINAL LAYER
WITH PARTS OF THE DIAPHRAGM

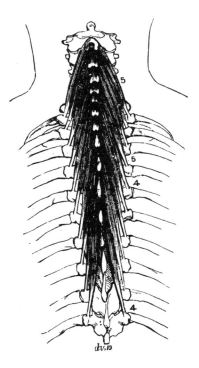

DEEP VERTEBRAL MUSCLES;
THE SEMI-SPINALES

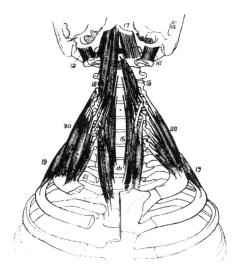

THE PRÆ-VERTEBRAL GROUP
WITH THE SCALENI

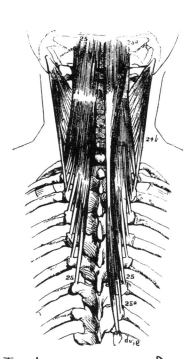

THE LONGITUDINAL DORSAL
GROUP IN THE NECK

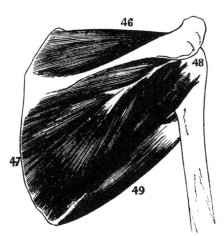

THE SCAPULAR GROUP

A.

B.

A.—POSTERIOR VIEW OF THE BODIES OF
FOUR VERTEBRÆ, ONE DORSAL & THREE
LUMBAR, TO SHOW POSTERIOR COMMON
LIGAMENT. —B.—ANTERIOR VIEW OF THE
ARCHES OF THE SAME VERTEBRÆ, TO SHOW
THE LIGAMENTA SUBFLAVA BETWEEN
THE LAMINÆ.

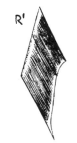

R'

Two very simple muscles have a *RHOMBOIDAL* shape, the so-called *RHOMBOID MUSCLES*, lesser and greater, of the scapula, R'. They are deep seated and consist merely of parallel fasciculi and narrow flat tendons.

RHOMBOID
MUSCLES

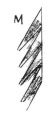

M

Extreme simplicity of form with its frequent concomitant *REPETITION* is seen in the *MULTIFIDUS MUSCLE* of the spine, M, which is composed of fleshy and tendinous bundles.

MULTIFIDUS
SPINAE

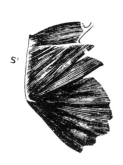

S'

GREAT SERRATUS
MUSCLE

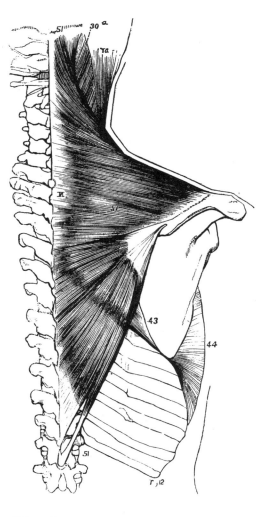

THE TRAPEZIUS OF THE
SUPERFICIAL DORSAL GROUP

## THE INFLUENCE OF THE MUSCULAR SYSTEM ON THE GENERAL AND LOCAL FORMS

The manifest influence of the muscles on the surface-forms of the body justifies the minutest examination of every detail concerning their form, structure, and connections. The deeper-seated muscles, in this respect, are of less importance than the superficial ones; they are hidden from view, but they serve to fill up the hollows, vacuities, and angular intervals existing in the hard framework of the body; they form the first fleshy clothing of the bones. The superficial muscles cover nearly every part of the skeleton, save only those subcutaneous parts.

In man, in whom the erect position demands a more uniform distribution of the muscular organs around the osseous columns of support, they nearly everywhere determine, by their position and mass, the outward general and local form of the body and limbs; they give breadth and smoothness to the trunk and special roundness and richness to the limbs; whereas, in quadrupeds, the body is more flattened on the sides, and the movements of the limbs are more

(Continued on page 20)

(Continued from page 26)

simply hingelike, to and fro, so that the muscles and tendons are placed chiefly in front of and behind the bones, and the general form of the limbs is also flattened laterally.

The introduction of long tendons in the limbs, especially in the leg and forearm, and on the toes and fingers, economizes the more highly organized contractile tissue, and conveys the action of the muscles conveniently to great distances, but it also aids in lightening the weight, and in tapering the general forms of the limbs in their distal segments, and thus adds greatly to their elegance and beauty. Unlike the straps and bands used in certain machinery, tendons, whether rounded or flat, never present quite straight borders or squared ends; their width continually varies, their edges are oblique or gently curved, and their attachments spread out so as not only to take a good hold of the bones to which they are fixed, but, if superficial enough, to blend finely and imperceptibly with the harder contours of these.

The forms of the deeper-seated muscles, including both their fleshy and their tendinous portions, are, for the most part, simple, their outlines being often geometrical, linear, triangular, or quadrangular, and their surfaces flat; but those of the superficial muscles, which are so far exposed that they actually determine the surface-forms, are as regards their tendons or aponeuroses, as well as their muscular portions, singularly complex both in outline and mass, presenting graceful contours and richly modelled surfaces of the most varied character, flowing agreably into each other.

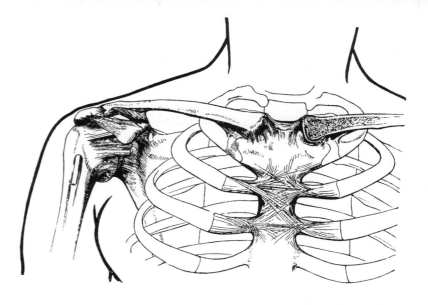

*The ligaments of the sternal, sterno, and those of the shoulder joint. The left interarticular fibro-cartilage. Tendons of clavicular, and scapulo-clavicular articulations sterno-clavicular joint is opened to show the capsular muscles on the shoulder joint.*

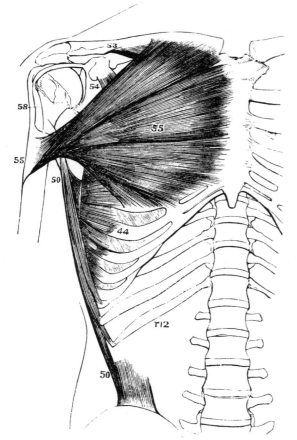

## The Pectoral Group with Part of The Latissimus Dorsi

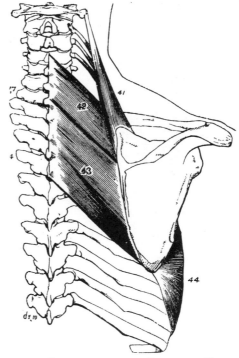

## The Shoulder-Girdle Group

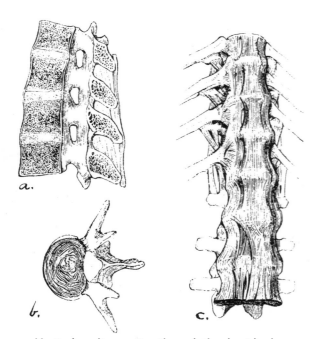

*a. Vertical median section through the dorsi-lumbar region of the spine, showing the intervertebral discs, the capsular ligaments, and the inter- and supraspinous ligaments; also a part of the spinal canal. b. Upper view of a Lumbar Vertebra, with transverse section of its intervertebral disc. c. Front view of four dorsal, and three lumbar vertebrae, showing the anterior common ligament, and the edges of the intervertebral discs; it also shows the costo-vertebral ligaments.*

(Continued on page 23)

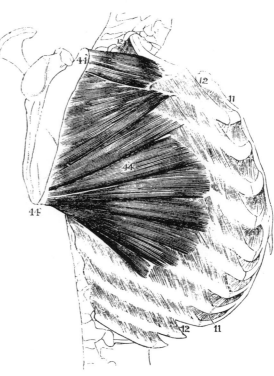

## The Great Serratus Muscle with the Scapula Lifted From the Chest

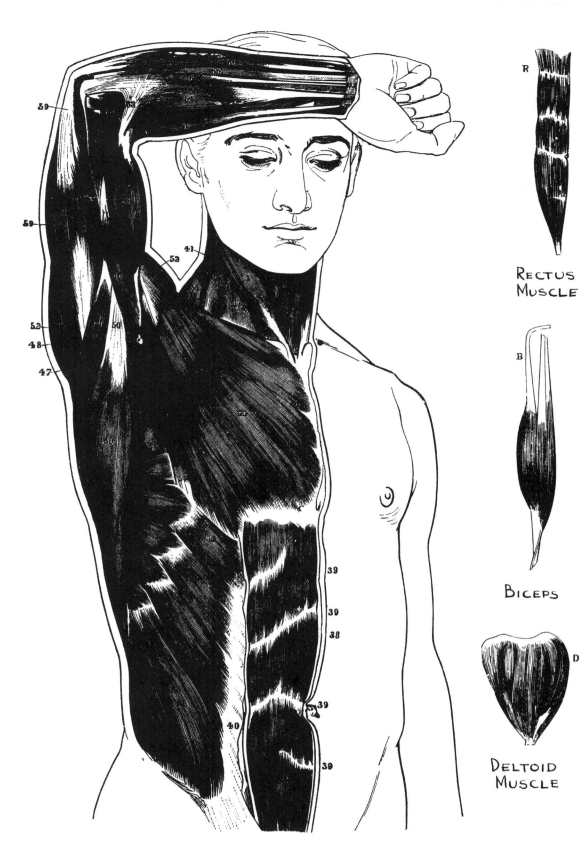

THE SURFACE MUSCLES OF THE TRUNK & UPPER LIMB

The rectus muscle of the abdomen furnishes the most striking instance of the existence of the tendinous inscriptions along the course of a muscle; they are indications of a segmentation of the soft parts, similar to those met with in the vertebral column and its appendages, the ribs.

RECTUS MUSCLE

BICEPS

DELTOID MUSCLE

## TABLE OF MUSCLES OF THE UPPER LIMB

*TRUNK AND UPPER LIMB*

Levator anguli scapulæ, 41

Rhomboideus minor, 42

Rhomboideus major, 43

Serratus magnus, 44

Subscapularis, 45

Supra-spinaus, 46

Infra-spinatus, 47

Teres minor, 48

Teres major, 49

Latissimus dorsi, 50

Trapezius, 51

Deltoid, 52

Subclavius, 53

Pectoralis minor, 54

Pectoralis major, 55

*THE ARM*

Coraco-brachialis, 56

Brachialis anticus, 57

Biceps, 58

Triceps, 59

Sub-anconeus

Anconeus, 60

*THE FORE-ARM*

Pronator quadratus, 61

Pronator teres, 62

Flexor carpi radialis, 63

Palmaris longus, 64

Flexor carpi ulnaris, 65

Flexor digitorum sublimis, 66

Flexor digitorum profundus, 67

Flexor longus pollicis, 68

Supinator brevis, 69

Supinator longus, 70

Extensor carpi radialis longior, 71

Extensor carpi radialis brevior, 72

Extensor carpi ulnaris, 73

Extensor communis digitorum, 74

Extensor minimi digiti, 75

Extensor indicis, 76

Extensor primi internodii pollicis, 78

Extensor secundi internodii pollicis, 79

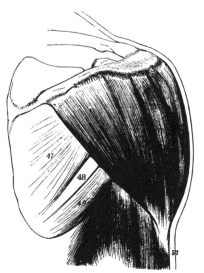

THE DELTOID MUSCLE FROM THE BACK

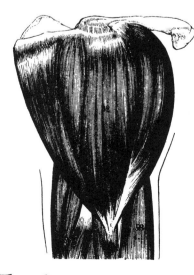

THE SAME FROM THE OUTER SIDE

(Continued on page 22)

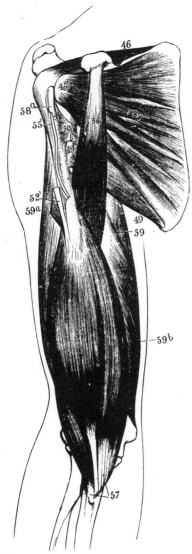

DEEP ANTERIOR AND
OTHER MUSCLES OF THE
ARM —

DELTOID MUSCLES FROM
THE FRONT

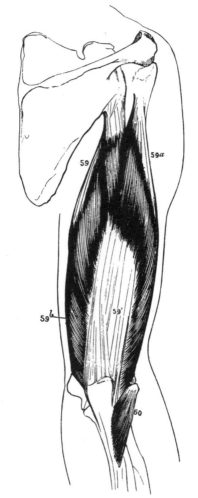

POSTERIOR MUSCLES OF
THE ARM AND ANCONEUS

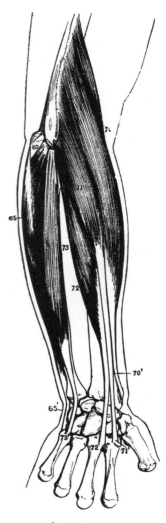

LONG SUPINATOR
AND EXTENSORS OF
THE WRIST

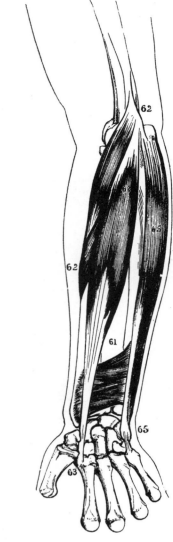

THE PRONATORS AND
THE FLEXORS OF THE
WRIST

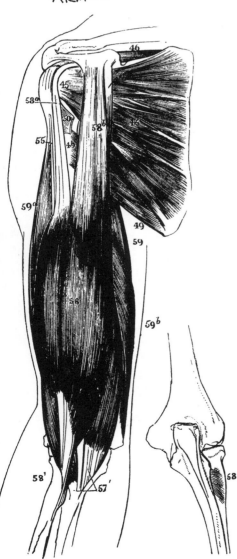

SUPERFICIAL ANTERIOR AND
OTHER MUSCLES OF THE ARM

PLATYSMA
MUSCLE

PECTORAL
MUSCLE

## TABLE OF MUSCLES

### (Continued)

*THE HAND*

Interossei dorsales, 80

Abductor minimi digiti, 80a

Abductor pollicis, 80b

Interossei palmares, 81

Adductor pollicis, 81a

Opponens pollicis, 82

Opponens minimi digiti, 82a

Lumbricales, 67a

Flexor brevis minimi digiti, 83

Flexor brevis pollicis, 84

Palmaris brevis, 85

(Palmar fascia, 64)

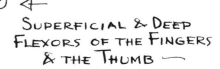

SUPERFICIAL & DEEP
FLEXORS OF THE FINGERS
& THE THUMB —

(Continued from page 20)

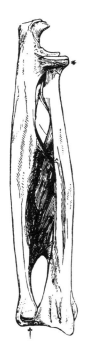

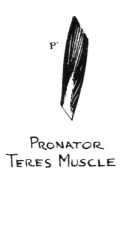

PRONATOR
TERES MUSCLE

*The Radio—ulnar Joints, show-
ing the orbicular ligament\*,
the oblique and the interosseus
ligaments, and the inter-articular
cartilage †, below.*

The local details of the surface-forms depend so much on the particular shapes of the individual muscles, their bulgings, flattenings, hollows, projections, ridges and curves, their fleshy and their tendinous or aponeurotic portions begin in this respect, of equal import-ance, that it is difficult to set limits to their study, which is replete with interest and utility. Many of the muscles possess such specialties of form and structure, that they may well lay claim to the character of individuality; they manifest the qualities of *SPECIALIZED* organs, and, one is tempted to say, simulate some of those of individual organisms.

The few muscles which are connected with soft parts only, are the simplest in both form and structure; they consist of flat, or curved planes, attached only to the mucous mem-branes, the skin, or the subcutaneous fascia; they merely move, and render tense, or throw into folds or close up, the parts with which they are connected. The platysma myoides, (page 22 — P), is an example of these.

The more numerous instances of muscles which are attached to bone at one end and to some soft tissue or organ at the other, have also simple forms. Such, for example, are the flat *CURVILINEAR PLANES* of fleshy fibres, named *ORBICULAR* muscles, which surround the mouth and eyelids, both of which serve to close the apertures which they embrace. (See page 15). Others, however, forming linear, triangular, or quadrilateral sheets of fleshy fasciculi, represented by the great zygomatic muscle of the mouth Z, page 15, draw upon the soft parts to which they are attached, and move them out of one position into another, in the direction of the muscle itself. In this category, all the other muscles which descend or ascend to reach the lips, may be classed; also those of the eyebrows and the various muscles in the orbit, which move the upper eyelid and the eyeballs; likewise certain muscular slips, which are attached to the capsules of joints; and lastly, the important tensor muscle of the fascia of the thigh.

(Continued on page 25)

TRICEPS
MUSCLE

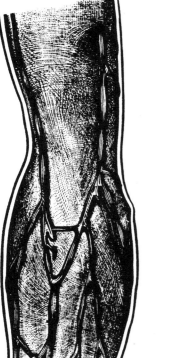

TIBIALIS
ANTICUS
MUSCLE

*Showing the Proper Fascia of a part of the
arm and forearm, with the Subcutaneous Veins
resting upon it, the superficial fascia and the
skin having been removed. The oblique offset
from the tendon of the biceps is also shown.*

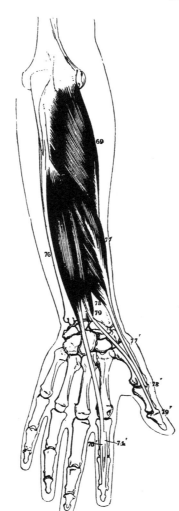

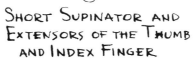

SHORT SUPINATOR AND
EXTENSORS OF THE THUMB
AND INDEX FINGER

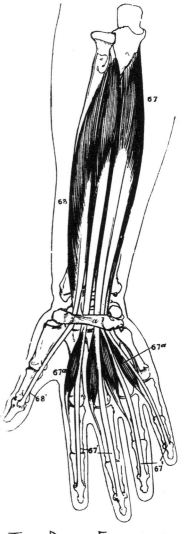

THE DEEP FLEXORS OF THE
FINGERS AND THUMB

23

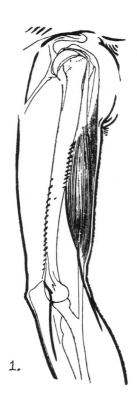

2.

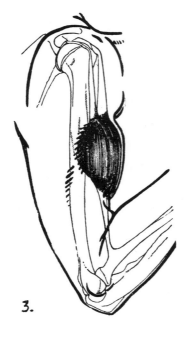

3.

1.

Most important changes of state in a muscle attached by both ends to bone, and their different effects on the surface-forms, are shown in the annexed representations of different conditions of the easily observed *BICEPS MUSCLE* of the arm, perhaps the most independent and freely moving muscle in the whole body. *Fig. 1*—the entire arm being dependent, the elbow-joint extended, and the forearm supinated, this muscle is perfectly tranquil, elongated to nearly its full extent. It is, accordingly, narrow and its surfaces present

gently curved forms. The posterior border of the muscle determines the agreeable curves of an *INTERMUSCULAR MARKING,* seen on the surface of the arm behind it, indicated in the sketch, by the series of cross lines over the anterior border of the humerus. In *Fig. 2*, the forearm being fully flexed, but now pronated, the biceps is in a state of strong, but not complete contraction. Its fleshy portion is much shortened and widened, its anterior contour is also shorter and more convex. Its posterior contour, with its coincident intermuscular surface marking, has also become more convex, and, as shown by the cross lines, has descended in the arm and no longer follows the anterior border of the humerus. In *Fig. 3*, the forearm being fully flexed and supinated, the muscle is completely contracted, so far, at least, as the bones will practically permit. Its length is now extraordinarily diminished.

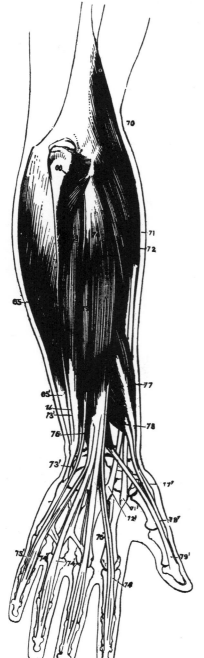

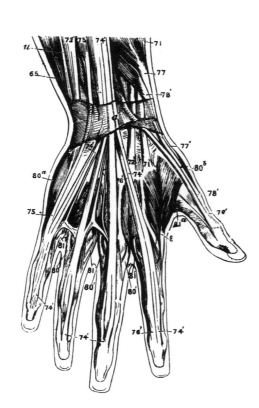

*Muscles and tendons on the back of the hand, with the posterior annular ligament, a.*

THE MUSCLES ON THE BACK OF THE FOREARM, COMPLETE

MUSCLES IN FRONT OF THE FOREARM, COMPLETE

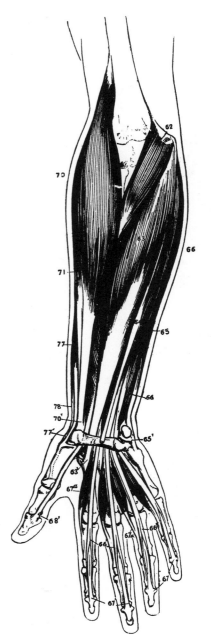

A.

A. The Ligaments and Joints of a Finger.

B. The Ligaments of the Thumb, including its Carpo-Metacarpal Joint

C. The Joints of the Thumb laid open

B.

(Continued from page 23)

It is the numerous muscles attached at both ends to the skeleton, and moving the bones on each other, which present the greatest variety of shape, structure, and connections. Most of them are larger in the center, and smaller at each end. Some muscles are *SHORT, ROUND, CONICAL, TAPERING,* or *SPINDLE-SHAPED*, like the pronator teres of the forearm, P', page 23, in which case, the fasciculi arise from a broader origin, and are gathered gradually upon the sides of a tapering tendon of insertion, narrower than the muscle itself. Many muscles are *TRIANGULAR* in shape as seen in the adductor longus of the thigh A, page 27, the muscular fasciculi radiating from a thick and narrow, to a thin and wide tendon. Numerous muscles have tendons of insertion as long as, or longer than their fleshy portions, such as some of the muscles of the leg and of the forearm, which proceed to the toes or fingers. The *BICEPS MUSCLE* of the arm, B, page 21, has one very long and slender tendon of origin; but it also possesses another tendon or origin and so is named the *BICIPITAL or TWO-HEADED*. The length of these two tendons of origin is determined by the fact, that there are overlying muscles, the tendons of which have to play over the biceps, while the biceps has to work beneath them; the fleshy part of this muscle is relatively short and fusiform, and consists of delicate and regular fasciculi, springing from the surface of the two tendons of origin, and ending, by an oblique border, on the surface of the tendon insertion, which, at first rounded, soon becomes flat, and undergoes a half twist, as it penetrates between the radius and the ulna, to reach

its point of insertion on the former bone. Again, a muscle may be *TRICIPITAL* or possessed of *THREE HEADS*, like the triceps of the arm, T, page 23, the separate portions of which, being too large to end on a round and tapering tendon, are gathered on to the under surface and borders of a broad flat tendon of insertion.

Under certain circumstances, multiplicity of origin from a series of similar bones arangement of the muscle itself, and to a *SERRATED* form at its edge, as seen in the great serratus muscle situated on the side of the thorax, S', page 19. A *COMPOUND TRIANGULAR* form, with two of the angles rounded off, occurs in the *GREAT PECTORAL MUSCLE* P'', page 22. Another modified *TRIANGULAR* form is seen in the well-known *DELTOID* or delta-shaped muscle of the shoulder D, page 21; this exhibits a remarkable internal structure, which serves to accumulate a vast number of short muscular fasciculi in a given space. The force of the *DELTOID* is not measured by a cross section through the widest part of the muscle, but by a series of vertical sections made through its numerous planes of oblique fasciculi. A fusiform muscle, with a fleshy origin, like the *TIBIALIS ANTICUS*, T', page 23, generally ends by its fasciculi fastening themselves obliquely to one edge of a long tendon, which appears as if gradually emerging from one side of the muscle, like a quill of a feather stripped of its barbs on one side; hence the muscle is said to be *SEMI-PENNIFORM*; the tendon is usually superficial, and frequently flattened, presenting one edge towards the skin, the muscular part reaching its under edge from the bone.

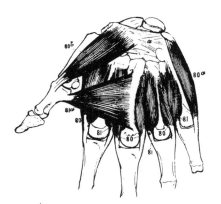

ABDUCTOR AND ADDUCTOR GROUP

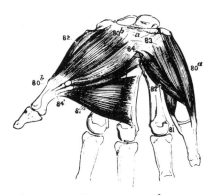

SHORT FLEXORS, ABDUCTORS, ADDUCTORS, & OPPONENT MUSCLES

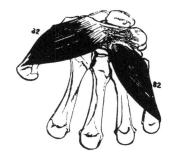

OPPONENT MUSCLES OF THE THUMB & LITTLE FINGER

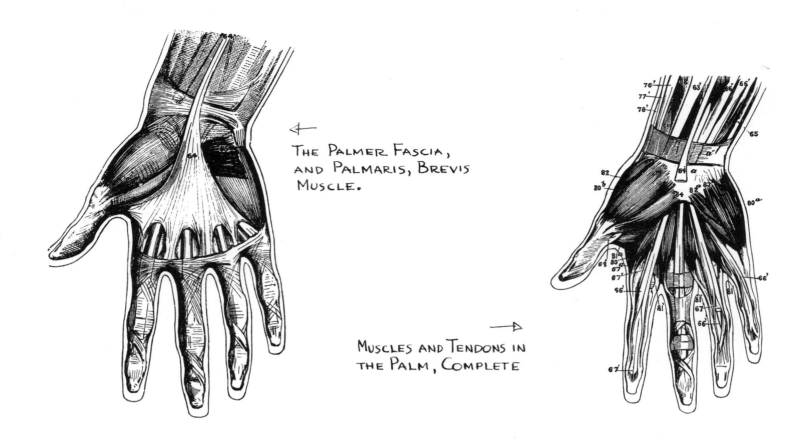

THE PALMER FASCIA,
AND PALMARIS, BREVIS
MUSCLE.

MUSCLES AND TENDONS IN
THE PALM, COMPLETE

The graceful tapering of the forearm is due to the transition of muscle into long tendons. Notice the angularity of the wrist and hands—this is because the bones are so near the surface. When drawing the whole figure or any of its parts, the artist should have the feeling of form, whether massive or angular— and it should be drawn with authority. Study the blocked-in figures in my book, *"FIGURES FROM LIFE"*—notice what an important part massive form plays in the preliminary drawings of the figure.

Make especially careful study of the construction of the *HANDS*. The hand is attached to the arm by the double row of *CARPAL BONES*. The carpal bones (the wrist) help to form a joint that has extreme freedom of motion—notice how you can rotate your hand in any direction.

The thumb side of the hand is a much heavier mass than the little-finger side. The back of the hand is shorter than the palm and it becomes narrower and thicker near the wrist. Except when the hand is clenched fist-fashion the back is quite flat. Hold your hand flat and open—fingers close together— note how the fingers taper toward the longest, the middle finger. Compare the length of each finger joint; also notice how the palm of the hand makes the length of the first joint half as long on the palm side as it is on the back side. The thumb hits the middle joint of the forefinger and it is as long as the middle finger. Study the construction of the details of the hand. Because of its complex parts and the greatly varied movements of the hand it is important not only to be able to draw the hands anatomically, but also learn to give hands the character that they portray.

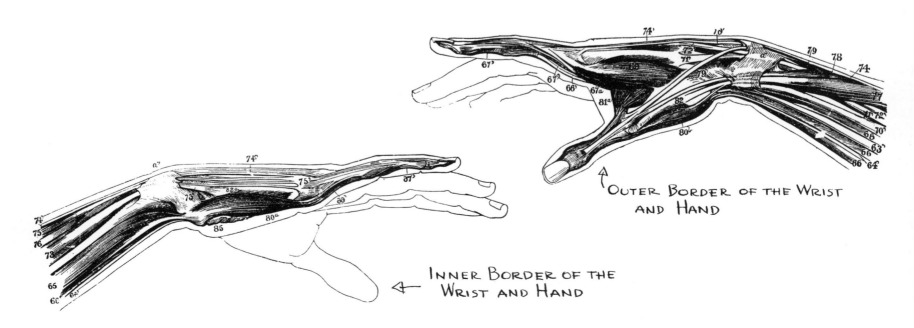

OUTER BORDER OF THE WRIST
AND HAND

INNER BORDER OF THE
WRIST AND HAND

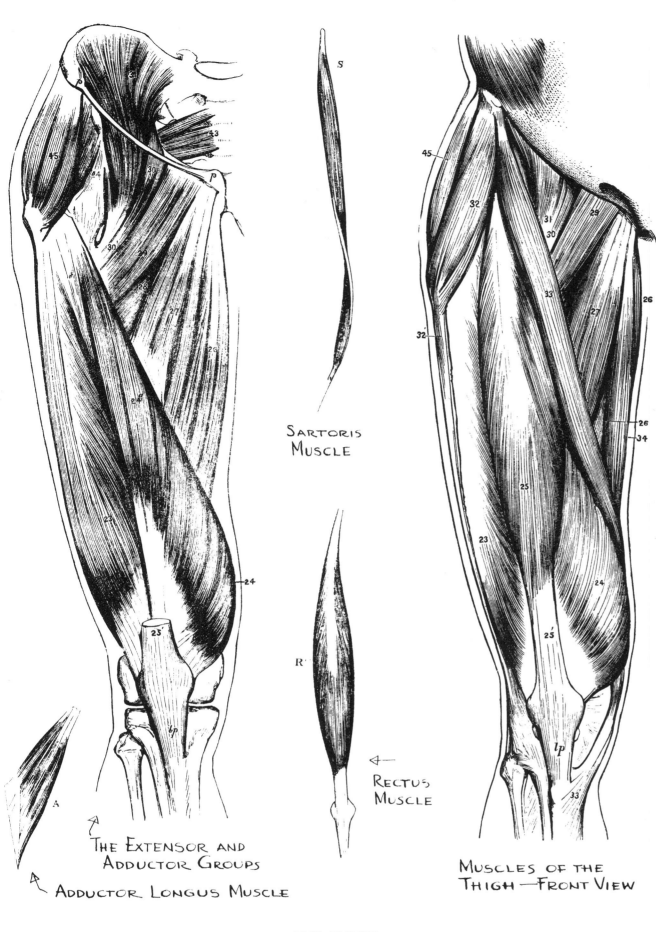

SARTORIS
MUSCLE

THE EXTENSOR AND
ADDUCTOR GROUPS

ADDUCTOR LONGUS MUSCLE

RECTUS
MUSCLE

MUSCLES OF THE
THIGH—FRONT VIEW

The *SARTORIUS MUSCLE* is the longest muscle in the body. It arises by tendinous fibers from the anterior superior iliac spine and the upper half of the notch below it—passing obliquely over the upper and anterior part of the thigh from the lateral to the medial side of the limb descending vertically as far as the medial side of the knee and then behind the medial condyle of the femur to end in a tendon.

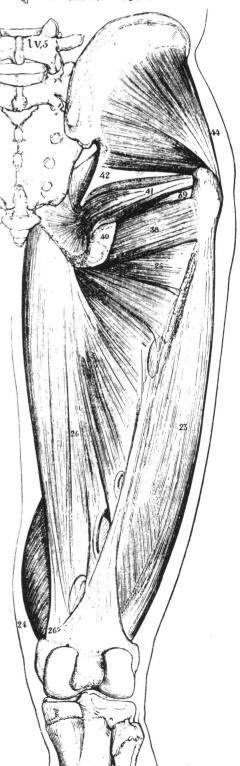

THE ROTATORS, VASTI, AND
GREAT ADDUCTOR

## THE THIGH

| | | |
|---|---|---|
| Vastus externus, 23 | Psoas magnus, 30 | Biceps cruris, 37a, 37b |
| Vastus internus, 24 | Psoas parvus | Quadratus femoris, 38 |
| Crureus, 24a | Iliacus, 31 | Obturator externus, 39 |
| Subcrureus | Tensor vaginae femoris, 32 | Gemellus inferior, 40 |
| Rectus femoris, 25 | (Fascia lata), 32' | Pyriformis, 43 |
| Adductor magnus, 26 | Sartorius, 33 | Gluteus minimus, 44 |
| Adductor longus, 27 | Gracilis, 34 | Gluteus medius, 45 |
| Adductor brevis, 28 | Semi-membranosus, 35 | Gluteus maximus, 46 |
| Pectineus, 29 | Semi-tendinosus, 36 | |

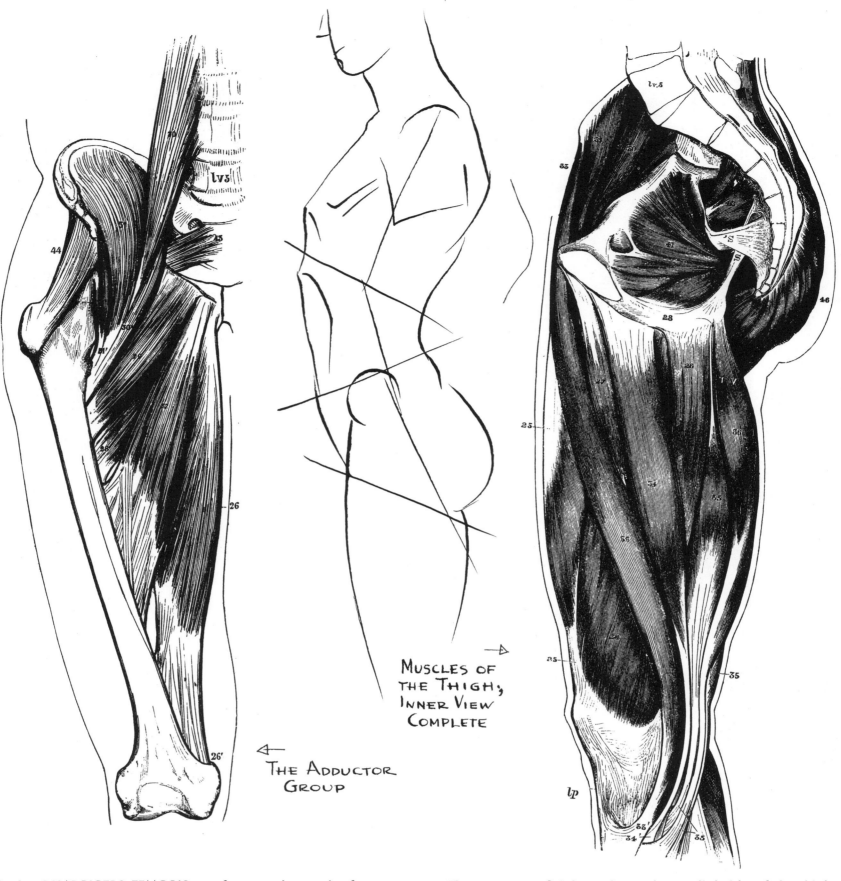

MUSCLES OF
THE THIGH;
INNER VIEW
COMPLETE

THE ADDUCTOR
GROUP

In the *QUADRICEPS FEMORIS* are four muscles on the front of the thigh. The *QUADRICEPS FEMORIS,* the great extensor muscle of the leg forms a large fleshy mass covering the front and sides of the femur. Each of its subdivisions is distinctively named;—the *RECTUS FEMORIS* occupying the middle of the thigh and is connected above with the ilium. Immediately connecting with the body of the femur are the other three—the *VASTUS LATERALIS* (vastus externus) on the lateral side of the femur; the *VASTUS MEDIALIS* covers the medial side; and the *VASTUS INTERMEDIUS* (vastus internus) in front.

The *SUCRUREUS* is a small muscle, occasionally blended with the *VASTUS* intermedius, but usually distinct from—arising from the anterior surface of the lower part of the body of the femur and inserted into the upper part of the synovial membrane of the knee-joint.

The most superficial muscle on the medial side of the thigh is the *GRACILIS*—thin and flattened, broad above, narrow and tapering below.

The most superficial of the *THREE ADDUCTORES* is the *ADDUCTOR LONGUS*—a triangular muscle lying on the same plane as the *PECTINEUS.*

Situated immediately behind the *PECTINEUS* and *ADDUCTOR LONGUS* is the *ADDUCTOR BREVIS*—a triangular-like form arising by a narrow origin from the outer surface of the *INFERIOR RAMUS* of the pubis between the *GRACILIS* and *OBTURATOR EXTERNUS.* Situated on the medial side of the thigh is the *ADDUCTOR MAGNUS,* a large triangular muscle, arising from a small part of the inferior ramus of the pubis, from the inferior ramus of the ischium, and from the outer margin of the inferior part of the tuberosity of the ischium.

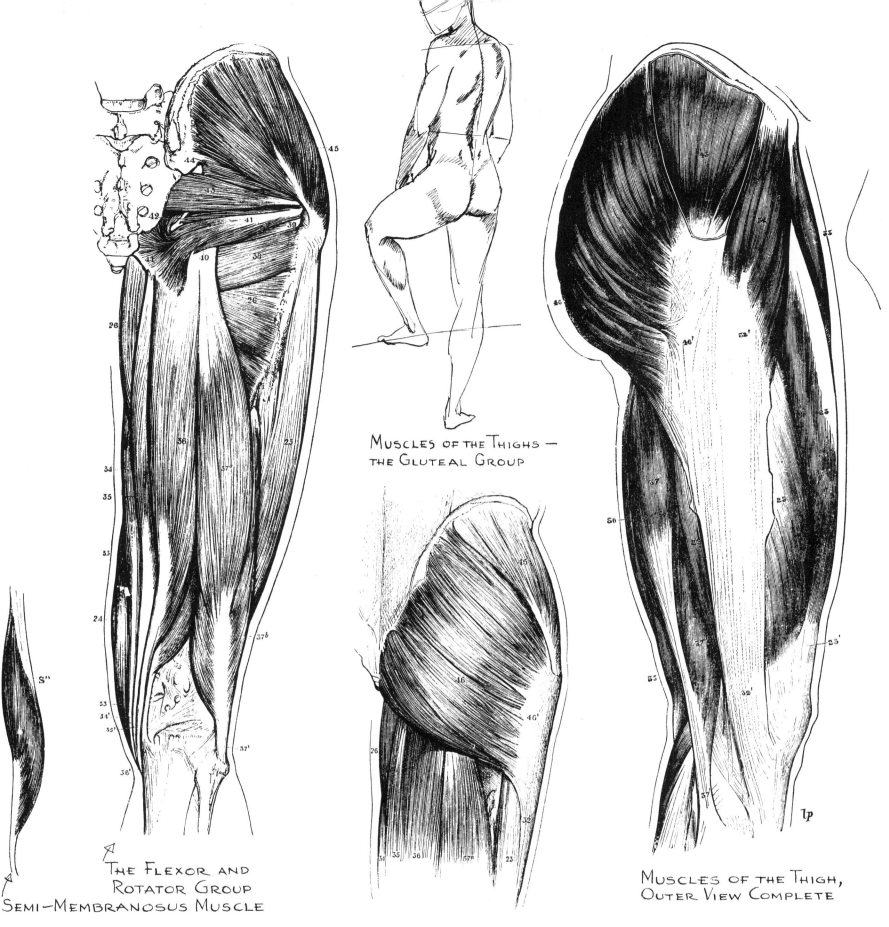

MUSCLES OF THE THIGHS —
THE GLUTEAL GROUP

THE FLEXOR AND
ROTATOR GROUP
SEMI-MEMBRANOSUS MUSCLE

MUSCLES OF THE THIGH,
OUTER VIEW COMPLETE

The most superficial muscle in the gluteal region is a broad and thick fleshy mass of a quadrilateral shape, the *GLUTEUS MAXIMUS*, forming the prominence of the nates (buttocks),— one of the most characteristic features of man's muscular system. The *GLUTEUS MAXIMUS* is remarkably course in structure—made up of fasciculi lying parallel with one another and collected together into large bundles separated by fibrus septa. The fibers are directed obliquely downward and lateralward from the posterior gluteal line of the ilium and the posterior surface of the lower part of the sacrum and the side of the coccyx, forming the upper and larger portion of the muscle together with the superficial fibers of the lower portion, ending in a thick tendinous lamina which passes across the great trochanter and is inserted in the iliotibial band of the fascia lata;—the deeper fibers of the lower portion are inserted into the gluteal tuberosity between the *VASTUS LATERALIS* and *ADDUCTOR MAGNUS*.

The *GLUTEUS MEDIUS*, a broad, thick, radiating muscle is situated on the outer surface of the pelvis—its posterior third being covered by the *GLUTEUS MAXIMUS* and its anterior two-thirds is covered by the gluteal aponeurosis which separates it from the superficial fascia and integument. A bursa separates the tendon of the muscle from the surface of the trochanter over which it glides.

The smallest of the three glutæi is the *GLUTEUS MINIMUS*— placed immediately beneath the preceding. The *GLUTEUS MINIMUS* is fan-shaped and arises from the outer surface of the ilium, between the anterior and inferior gluteal lines and behind the great sciatic notch. The deep surface of the *GLUTEUS MINIMUS* lies in relation with the reflected tendon of the *RECTUS FEMORIS* and the capsule of the hip-joint.

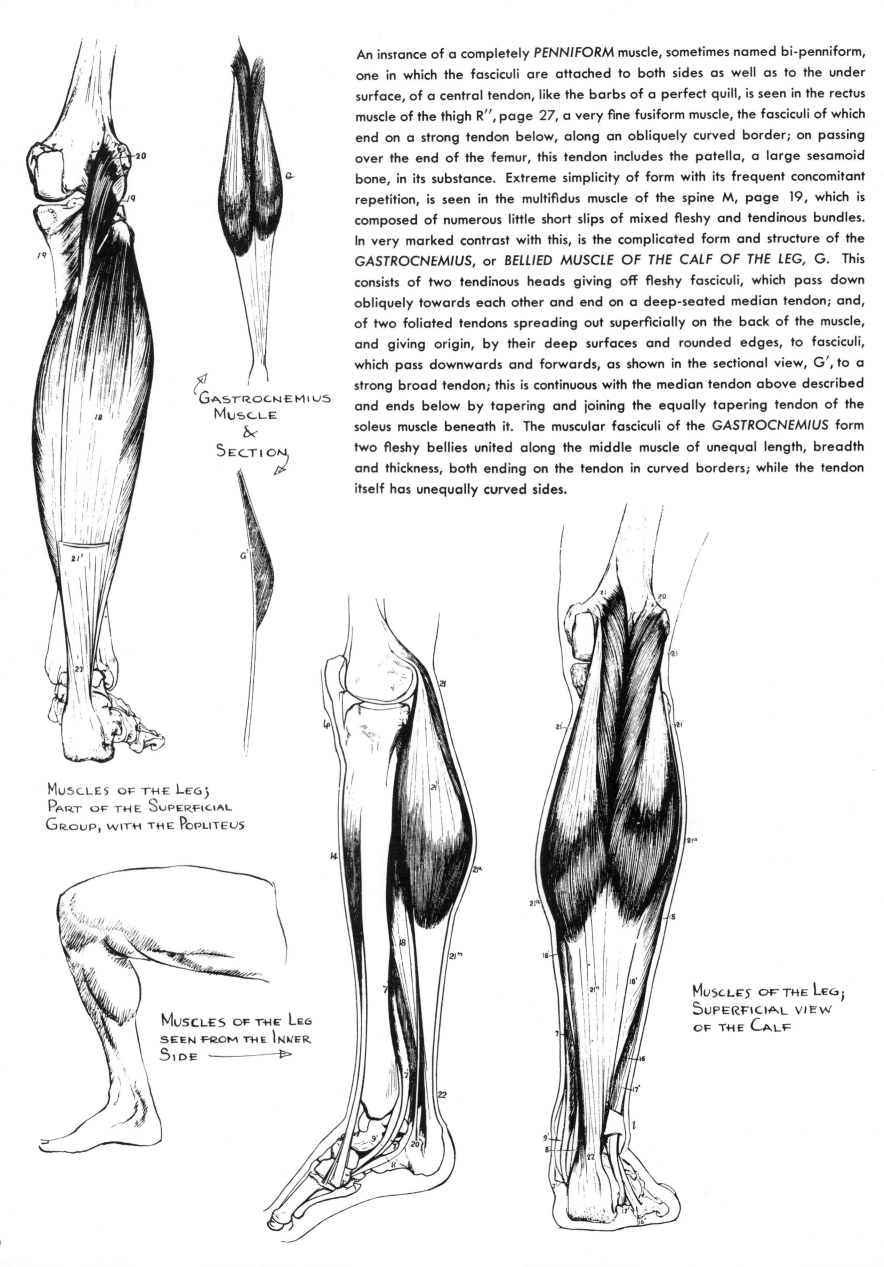

An instance of a completely *PENNIFORM* muscle, sometimes named bi-penniform, one in which the fasciculi are attached to both sides as well as to the under surface, of a central tendon, like the barbs of a perfect quill, is seen in the rectus muscle of the thigh R'', page 27, a very fine fusiform muscle, the fasciculi of which end on a strong tendon below, along an obliquely curved border; on passing over the end of the femur, this tendon includes the patella, a large sesamoid bone, in its substance. Extreme simplicity of form with its frequent concomitant repetition, is seen in the multifidus muscle of the spine M, page 19, which is composed of numerous little short slips of mixed fleshy and tendinous bundles. In very marked contrast with this, is the complicated form and structure of the *GASTROCNEMIUS*, or *BELLIED MUSCLE OF THE CALF OF THE LEG,* G. This consists of two tendinous heads giving off fleshy fasciculi, which pass down obliquely towards each other and end on a deep-seated median tendon; and, of two foliated tendons spreading out superficially on the back of the muscle, and giving origin, by their deep surfaces and rounded edges, to fasciculi, which pass downwards and forwards, as shown in the sectional view, G', to a strong broad tendon; this is continuous with the median tendon above described and ends below by tapering and joining the equally tapering tendon of the soleus muscle beneath it. The muscular fasciculi of the *GASTROCNEMIUS* form two fleshy bellies united along the middle muscle of unequal length, breadth and thickness, both ending on the tendon in curved borders; while the tendon itself has unequally curved sides.

GASTROCNEMIUS MUSCLE & SECTION

MUSCLES OF THE LEG; PART OF THE SUPERFICIAL GROUP, WITH THE POPLITEUS

MUSCLES OF THE LEG SEEN FROM THE INNER SIDE

MUSCLES OF THE LEG; SUPERFICIAL VIEW OF THE CALF

MUSCLES OF THE LEG;
ANTERIOR GROUP

MUSCLES OF THE LEG;
DEEP POSTERIOR GROUP

MUSCLES OF THE LEG;
OUTER OR PERONEAL
GROUP

## TABLE OF MUSCLES OF THE LEG

Tibialis anticus, 14

Extensor proprius pollicis pedis, 12

Extensor longus digitorum pedis, 11

Peroneus tertius vel anticus, 15

Peroneus brevis, 16

Peroneus longus, 17

Tibialis posticus, 9

Flexor longus pollicis pedis, 8

Flexor longus digitorum pedis, 7

Soleus, 18

Popliteus, 19

Plantaris, 20

Gastrocnemius, 21

(Tendo Achillis), 22

LIGAMENTS OF THE TOES
AND METATARSUS; THE
JOINTS OF THE TOES
LAID OPEN

MUSCLES IN THE
SOLE OF THE FOOT
ABDUCTOR GROUP.

DEEP FLEXOR
GROUP, WITH TWO
ABDUCTORS
& AN
ADDUCTOR

## TABLE OF MUSCLES OF THE FOOT

Interossei, dorsales pedis (four), 1

Interossei, plantares pedis (three), 2

Abductor Minimi digiti, pedis, 1a

Abductor pollicis pedis, 1b

Adductor pollicis pedis, 2b

Transversus pedis, 3

Flexor brevis minimi digiti pedis, 4

Flexor brevis pollicis pedis, 5

Flexor Accessorius, 7a

Lumbricales pedis (four), 7b

Flexor brevis digitorum pedis, 6

Extensor brevis digitorum pedis, 10

(Annular ligaments), a, a

MUSCLES & TENDONS ON
THE DORSUM OF THE FOOT,
WITH THE
ANNULAR LIGAMENT a', a".

THE PLANTAR FASCIA

MUSCLES OF THE SOLE OF
THE FOOT. ACCESSORY
FLEXOR, LUMBRICALES
& LONG TENDONS.

SUPERFICIAL VIEW OF
THE SHORT FLEXOR,
WITH OUTER MUSCLES
COMPLETE.

MUSCLES & TENDONS ON THE
OUTER BORDER & DORSUM OF
THE FOOT, WITH THE ANTERIOR
ANNULAR, a, & EXTERNAL
ANNULAR LIGAMENT.

MUSCLES & TENDONS ON THE BORDER
OF THE FOOT, WITH THE ANTERIOR
& INTERNAL ANNULAR
LIGAMENTS, a, a.

31

# Walter Foster Art Instruction Program

## THREE EASY STEPS TO LEARNING ART

**Beginner's Guides** are specially written to encourage and motivate aspiring artists. This series introduces the various painting and drawing media—acrylic, oil, pastel, pencil, and watercolor—making it the perfect starting point for beginners. Book One introduces the medium, showing some of its diverse possibilities through beautiful rendered examples and simple explanations, and Book Two instructs with a set of engaging art lessons that follow an easy step-by-step approach.

**How to Draw and Paint** titles contain progressive visual demonstrations, expert advice, and simple written explanations that assist novice artists through the next stages of learning. In this series, professional artists tap into their experience to walk the reader through the artistic process step by step, from preparation work and preliminary sketches to special techniques and final details. Organized by medium, these books provide insight into an array of subjects.

**Artist's Library** titles offer both beginning and advanced artists the opportunity to expand their creativity, conquer technical obstacles, and explore new media. Written and illustrated by professional artists, the books in this series are ideal for anyone aspiring to reach a new level of expertise. They'll serve as useful tools that artists of all skill levels can refer to again and again.

Walter Foster products are available at art and craft stores everywhere.
For a full list of Walter Foster's titles, visit our website at www.walterfoster.com
or send $5 for a catalog and a $5-off coupon.

WALTER FOSTER PUBLISHING, INC.
23062 La Cadena Drive
Laguna Hills, California 92653
Main Line 949/380-7510
Toll Free 800/426-0099

www.walterfoster.com